Title: Building Study
Projection: two-point
Medium: felt-tip color markers and color transparencies

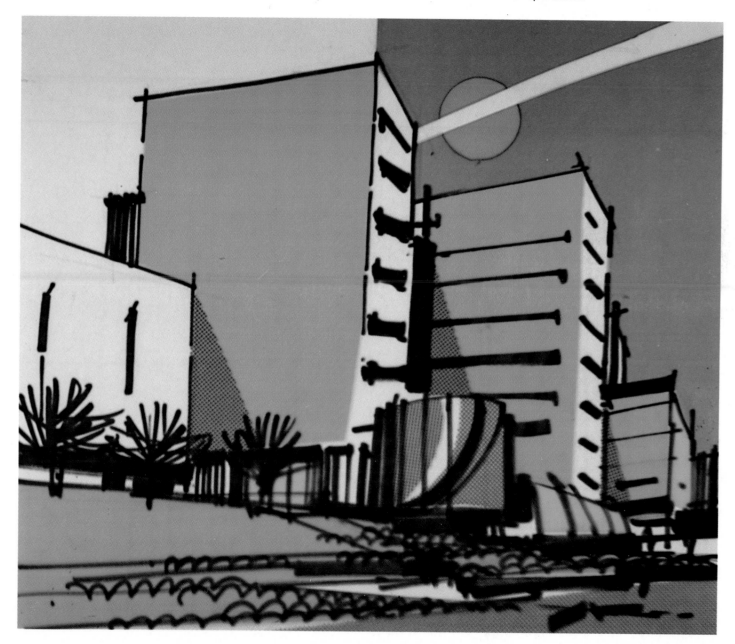

Title: Streetscene
Projection: one-point
Medium: felt-tip color markers on marker
paper

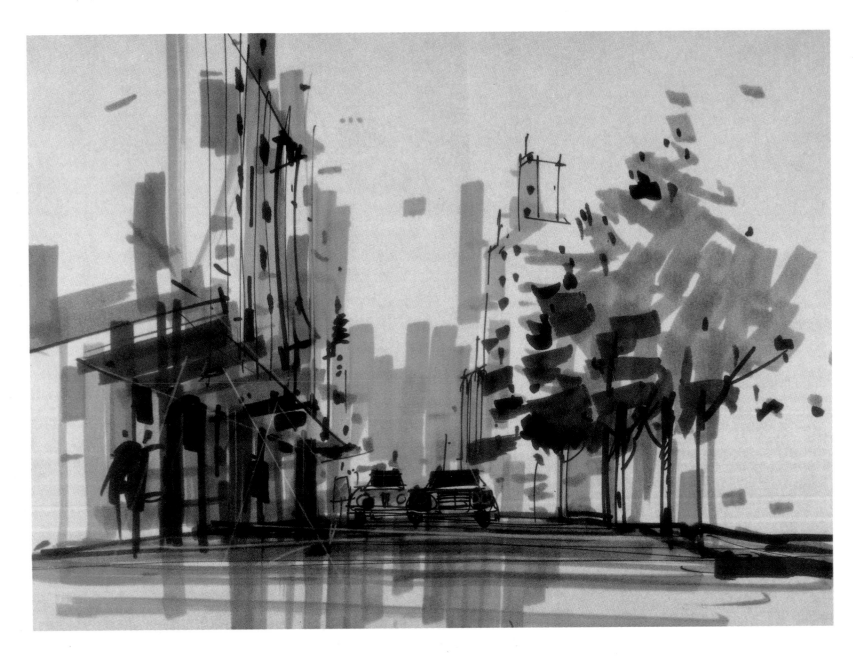

Projection Drawing

Projection Drawing

Thomas C. Wang

VNR VAN NOSTRAND REINHOLD COMPANY

To my son Andrew

Printed in the United States of America
Designed by Thomas C. Wang

Published by Van Nostrand Reinhold
Company Inc.
135 West 50th Street
New York, New York 10020

Van Nostrand Reinhold Company Limited
Molly Millars Lane
Wokingham, Berkshire RG11 2PY, England

Van Nostrand Reinhold
480 La Trobe Street
Melbourne, Victoria 3000, Australia

Macmillan of Canada
Division of Gage Publishing Limited
164 Commander Boulevard
Agincourt, Ontario M1S 3C7, Canada

16 15 14 13 12 11 10 9 8 7 6 5 4 3 2 1

**Library of Congress Cataloging in
Publication Data**

Wang, Thomas C.
 Projection drawing.

 Bibliography: p.
 Includes index.
 1. Projection. 2. Perspective. I. Title.
T362.W36 1984 604.2'45 83-25930
ISBN 0-442-29232-5
ISBN 0-442-29231-7 (pbk)

CONTENTS

PREFACE

The purpose of this book is twofold: first to present a short course in orthographic and perspective projections and second to discuss the reasons for the importance of projection drawings in a design process.

It is not a book on the history of perspective nor does it intend to emphasize the technical precision of the architectural projections. Readers are urged to regard the mathematical part of the presentation merely as a means to help them better understand the liveliness and adaptability of such mechanisms during their own design explorations.

The designers

INTRODUCTION

The design process is indisputably a linear process. It can be systematically divided into various stages according to the tasks performed and the timing of these performances. Herman Von Helmholtz described this creative process in four steps: saturation, incubation, illumination, and verification. Designers work with visual images: we produce visual images; we think in pictorial images; and we engage in visual dialogues. Whether he is concerned with the articulation of space or the choice of a certain fabric, a designer must constantly use drawings to communicate his feelings, his design options, his decisions, and his judgment.

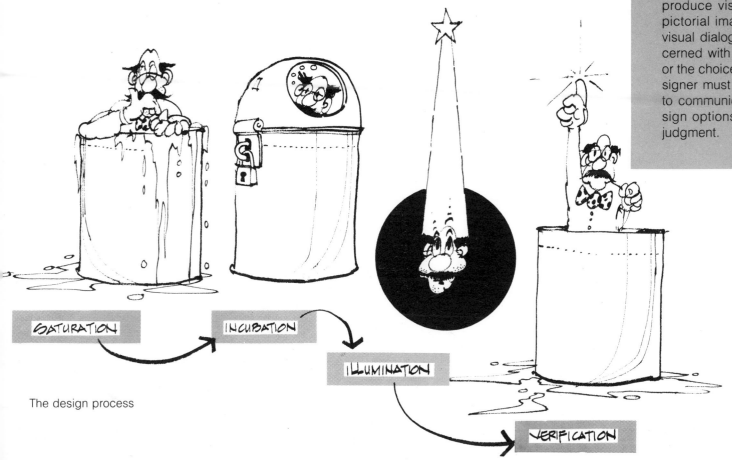

The design process

9

A designer must not only create mental images but he must know how to translate these pictorial thoughts into the "real thing." Obviously, one can build or make the real thing immediately after visualization in the mind. This, however, tends to be rather risky because of the scope of contemporary design projects. Alteration during the construction of such real things can be extremely costly and time consuming. In today's design professions, drawings are an indispensable step between the creative mind and the product. Drawings help track one's ideas. They help record and organize one's thoughts. They are a sounding board for new thoughts and ideas for improving a design. Design drawing is a language used to communicate with the clients. It can also serve as a legal document. Drawing is above all a self-communication tool. Drawing is such an important element of a design process that it cannot be thoughtlessly bypassed. The assumption of this book is that more drawings will lead to a better design.

Sketch of a courtyard (A)

Sketch of a courtyard (B)

The art of drawing (sketching) involves the eyes, the brain, and the hands in a dynamic cycle that produces better ideas one after another. If a designer can master the art and can graphically speak the language, better design can be generated in a shorter period of time. The critical point here is the ability to do it well; since drawings are pictorial representations of the real thing to be, and the real thing is to be seen, the drawings must be able to simulate visual experience and sensation. They must convey depth in space and their content must be proportionally accurate. The angle of projection must correlate with the actual viewing angle of prospective viewers.

In order to simulate the experience of seeing the real product, the designer must be familiar with the projection system and must know when and how to apply it. Most publications separate projection from the art of sketching. It is handled in a very technical fashion, which creates a mystique that in many ways hampers the

effective learning of such methods, and of sketching as well. The primary objective of this book is to discuss these two aspects of drawing for design together and to emphasize the ease with which they can be learned.

This book is directed toward all entry-level design students. By laying the foundation for a better and more creative visualization process, I hope that better designers will be produced.

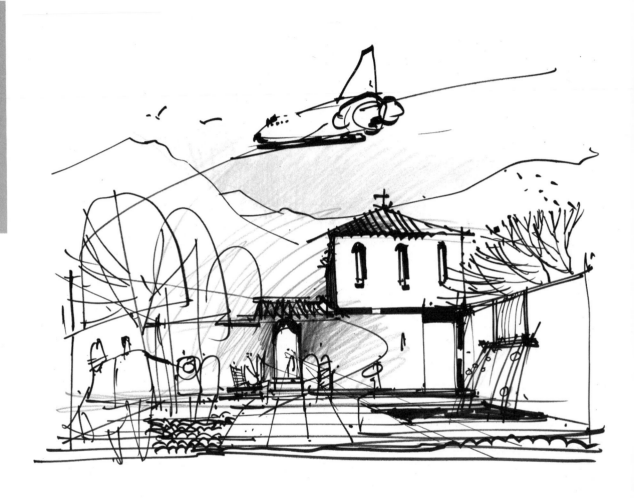

Sketch of a courtyard (C)

DESIGN DRAWING

The primary purposes of design drawings are to document the design process and to describe the design product. Here I am referring not to the different kinds of design drawings but to one category of drawing, which can metamorphose and take on different appearances.

Design drawing is a living organism that grows in time. It matures and gradually reveals its characteristics and meets its purposes as the designer continues the nurturing by molding and reshaping it. Although sometimes it is important for the designer to discard the previous drawings and start afresh with a new image, a drawing must bear certain likenesses to its predecessors and, at the same time, allow room for future growth and transformation. Use of overlays and photographic reproduction permit such a process of evolution.

Design drawing

Physical Description

The first function of a design product drawing is to accurately record the measurements of the product's physical structure. These dimensions are often recorded in plans, sections, elevations, and other forms of parallel projections. These projections were chosen because of their ability to retain time measurements (through scaling) and right angles. They eliminate pictorial distortion and are considered to be true projection. All the dimensions and some of the angles from these drawings can be measured to the scale to which they are drawn.

Title: Building Study
Projection: elevation
Medium: color markers on brownline print

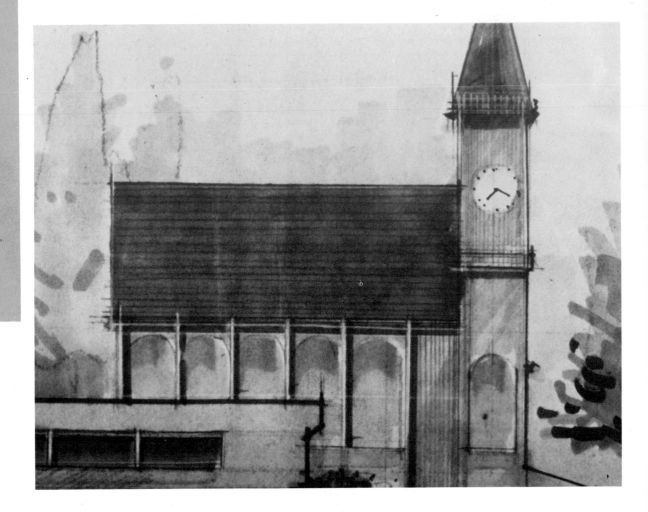

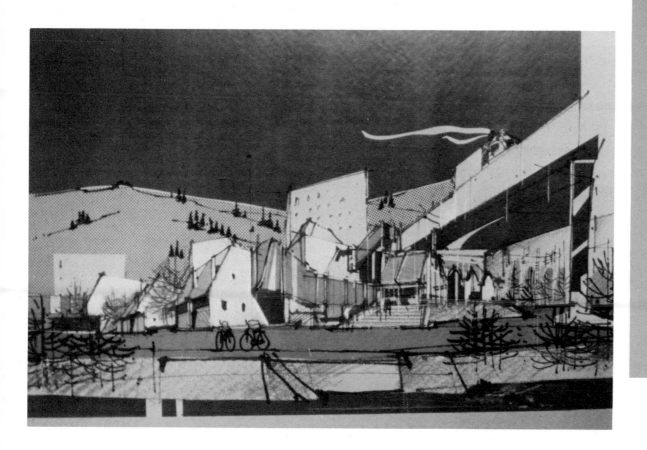

Qualitative Description

The second function of design drawings is to describe graphically the design quality and atmosphere. These intangible characteristics are usually very difficult to express in parallel projection because of its inability to simulate the sensation of spatial depth, so perspective projections are used. These projections, together with accurate expression of materials, texture, color, and composition, can become a very effective graphic essay. Perspective is an illusion that allows the viewer to interact freely with the drawing. On the other hand, parallel projections separate the viewer from the picture because they do not take into account the viewer's position.

Title: Riverfront Development (I)
Projection: two-point
Medium: black felt-tip marker on illustration board, garnished with color Zip-a-tone and white pencil

THE TYPES OF PROJECTIONS

Graphic communication is like a form of language. This picture language differs from spoken ones because of its universality. There are numerous spoken and written languages whereas there is only one graphic language. It works across cultural and ethnic barriers and delivers powerful messages by means of combinations of symbols, patterns, and colors.

Most of the picture language is based upon a picture-plane projection. The picture plane is an imaginary transparent vertical surface perpendicular to our sight line, which is basically horizontal. The picture plane intercepts all projection rays extended from the object toward the viewer. The intercepted image is therefore called a projection.

There are two major projections, parallel line and perspective. In the case of parallel-line projection, the projection rays are all parallel with each other. In perspective projection, all projection rays extended from the object converge at the viewer's eye. The converging rays vanish, creating an illusion of depth and producing an image that violates our intellect but stimulates our visual sensation.

It is this sensation that generates comparison between what we actually see (which has depth) and what we see on paper. Perspective drawings go beyond parallel graphics and are visually deceptive. But that is why they work.

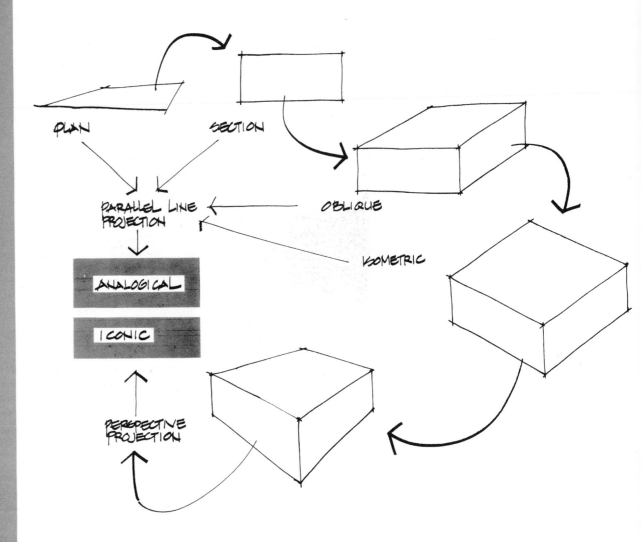

Types of projections

16

Title: Streetscene
Projection: elevation
Medium: black felt-tip marker and color
Zip-a-tone

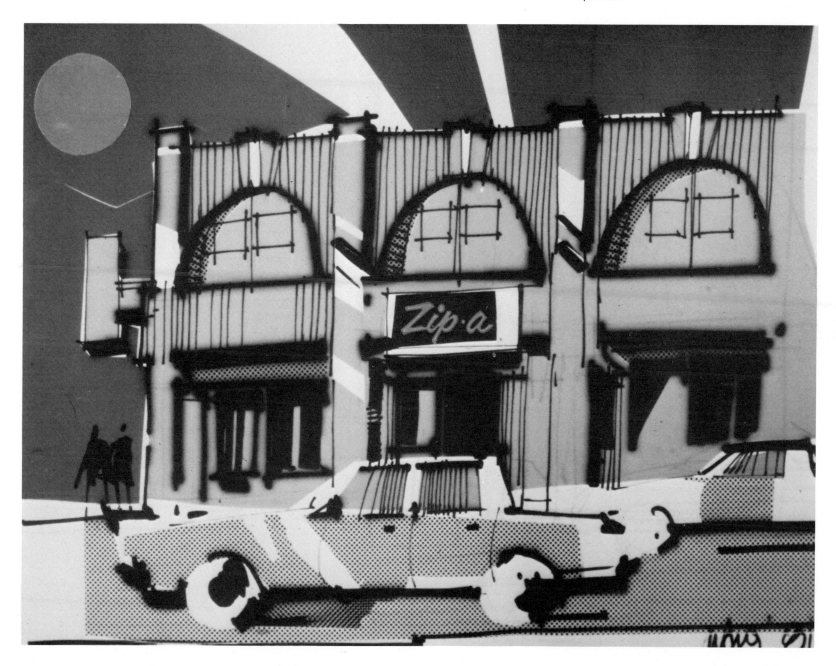

17

Title: Riverfront Development (II)
Projection: two-point
Medium: black felt-tip marker on
illustration board, garnished with color
Zip-a-tone and color pencils

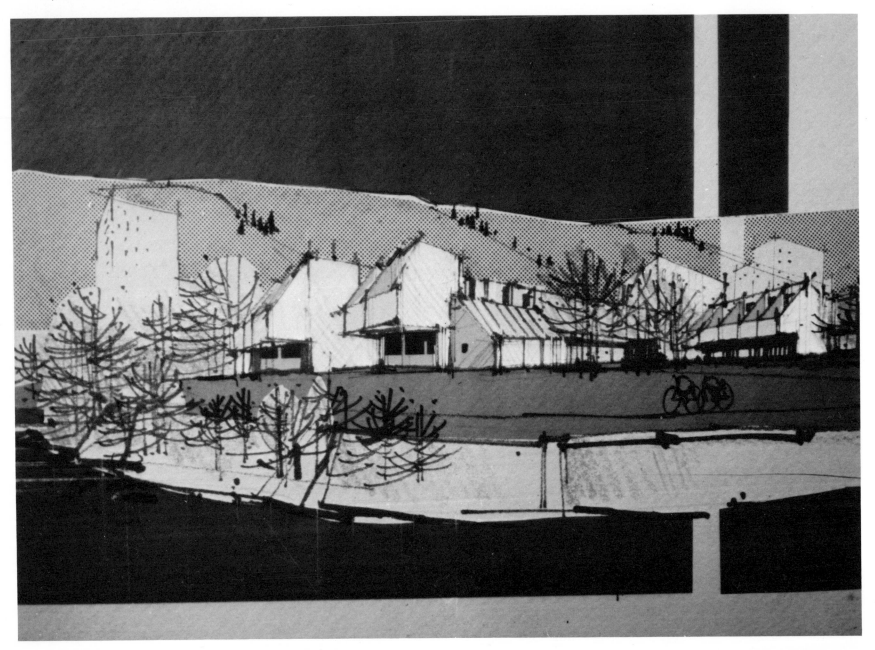

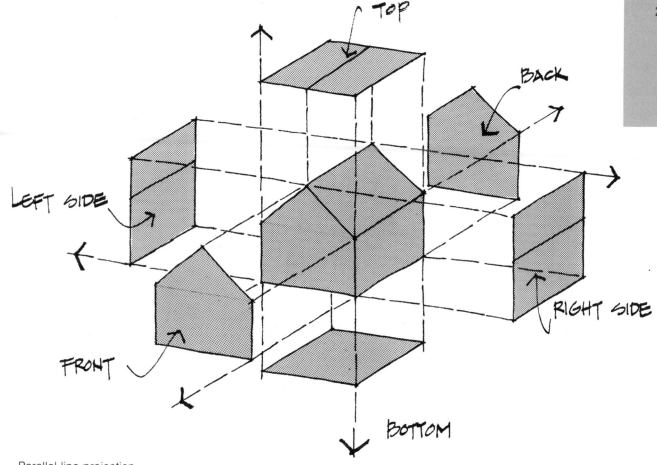

TOP

BACK

LEFT SIDE

RIGHT SIDE

FRONT

BOTTOM

Parallel-line projection

1. Definition: A graphic image of a three-dimensional object in which the projection rays are all parallel to each other (see illustration).

2. Features
 a. Lines that are parallel in the object remain parallel in the constructed projection.
 b. All dimensions in the projection may be scaled.

3. Glossary

Horizon: eye-level.

Object: A 3-dimensional shape to be graphically described.

Observer: refers to the viewing position but does not suggest the position of the eye(s).

Picture plane: an imaginary transparent surface that intercepts the projection rays.

Projection rays: imaginary sight lines that extend from the observer to the object being described.

4. Characteristics

a. Projection rays and picture plane are always perpendicular to each other.

b. The number of projection rays is dependent upon the complexity of the object to be described.

c. The picture plane is perpendicular to the horizon line.

d. The position of the picture plane has no bearing on the site of the projection drawing.

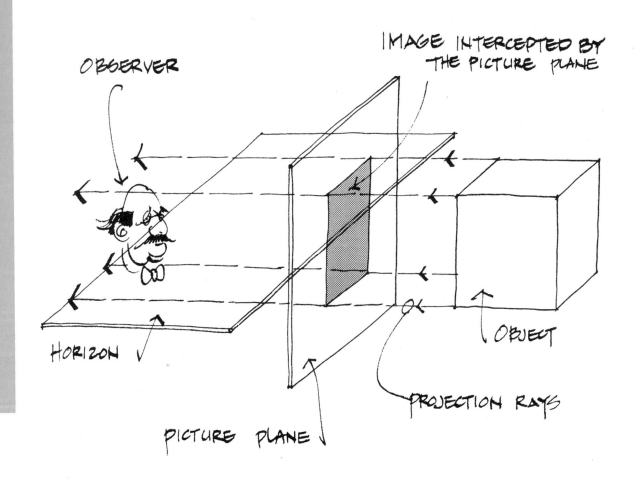

Operation of parallel-line projection

Types of parallel-line projections

Types of Parallel-Line Projections

Orthographic Projection: Parallel-line projection is a single view of an object in which the view is projected along lines (projection rays) perpendicular to both the picture plane (drawing surface) and the frontal planes of the object (see illustration).

Multiview Projection: Parallel-line projection of a single view of an object that is positioned so that its principal face (i.e., frontal plane) is drawn parallel to the picture plane (drawing surface). Multiview drawings are usually made up of a cluster of three projections but a complex object may require a greater number of views (maximum, 6). Multiview projection is extremely useful in engineering and industrial design. It is also an indispensable graphic component of architectural details.

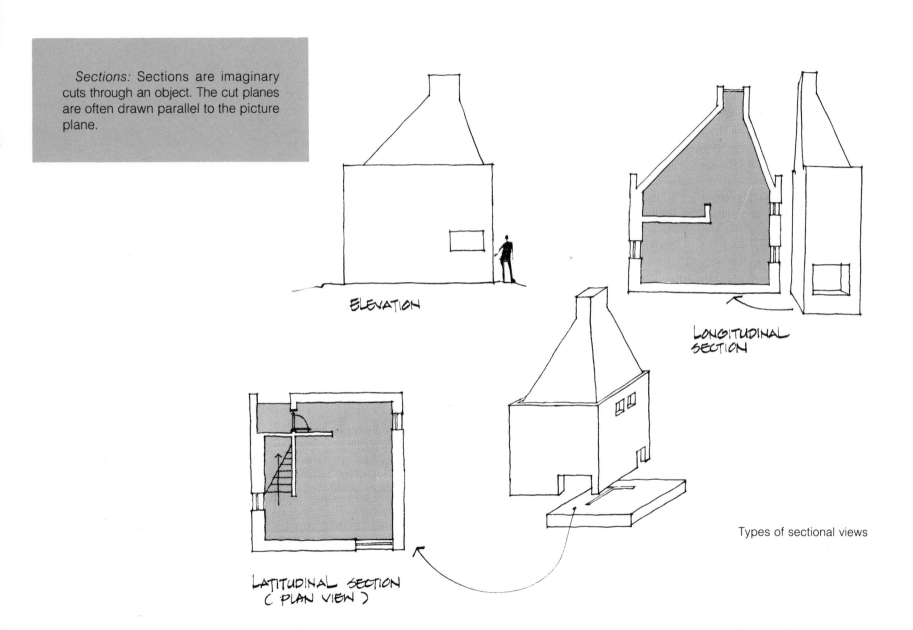

Sections: Sections are imaginary cuts through an object. The cut planes are often drawn parallel to the picture plane.

ELEVATION

LONGITUDINAL
SECTION

LATITUDINAL SECTION
(PLAN VIEW)

Types of sectional views

Multiview transfer procedure

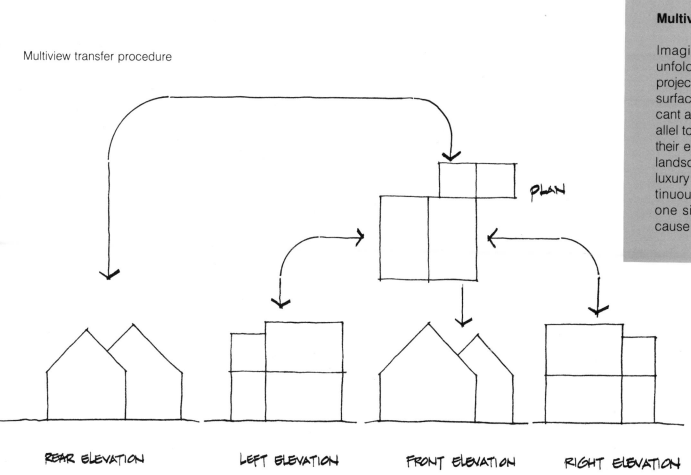

PLAN

REAR ELEVATION LEFT ELEVATION FRONT ELEVATION RIGHT ELEVATION

Imagine multiview projection as an unfolded box (see illustration). The projections are arranged so that all the surfaces (the bottom view is insignificant and therefore excluded) are parallel to each other and can be seen in their entirety. In most architectural and landscape-architectural drawing the luxury and effectiveness of this continuous projection must give way to one single sheet for each view because of the large scale of the project.

23

A. Direct Projection: lines are dropped perpendicularly down or horizontally across the sheet from the drawn object in order to plot the next view. A T-square and triangle are indispensable for this type of transfer.
B. Scale: dimensions are transferred by measuring them and redrawing them at the appropriate locations.
C. Dividers: measurements are transferred to by the divider.
D. 45-degree Miter Line: for projection not directed below or across from the plan view, lines are drawn as shown, intercepted by the 45-degree line, and stopped perpendicularly to construct the new image.

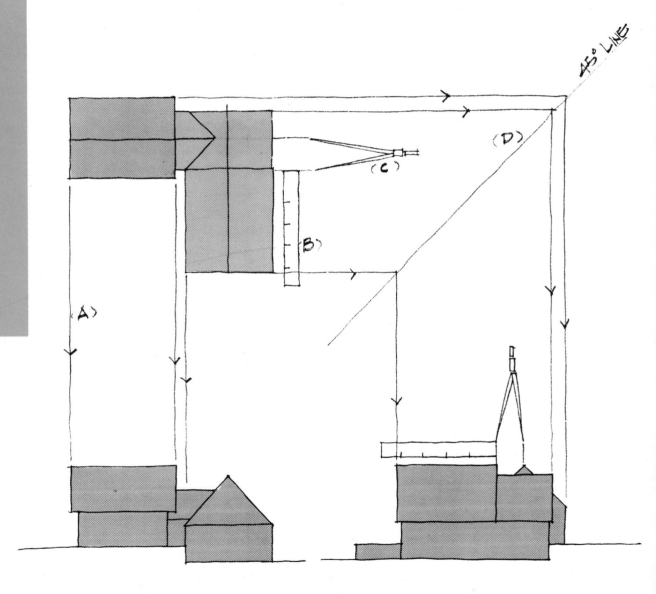

Multiview transfer techniques

Oblique projection

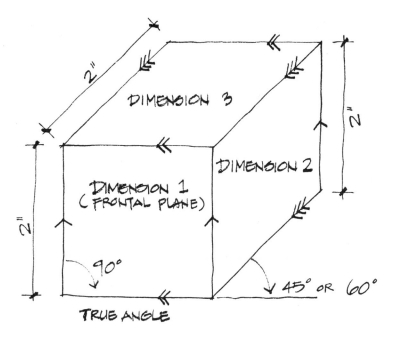

DIMENSION 3

2"

2"

DIMENSION 2

DIMENSION 1
(FRONTAL PLANE)

2"

90°

TRUE ANGLE

45° OR 60°

SIDE VIEW AS FRONTAL PLANE

PLAN VIEW AS FRONTAL PLANE

Axonometric Projection

Axonometric projection is a single-view drawing of an object that appears to be inclined and shows all three principal sides. Projection lines are all drawn parallel to one another and the dimensions of such projection can be measured (see illustration).

Oblique Projection: Parallel-line single-view projection of an object in which only the frontal planes are drawn parallel to the picture plane (drawing surface). The other two faces (depth) are drawn oblique to the drawing surface. The degree of inclination is often shown in 45 degrees. Because of the nature of all parallel-line projections, the receding lines of these two planes do not converge and consequently appear to be distorted. This can be minimized by (1) changing the depth dimension to one half the true measurement and (2) positioning so that the largest dimension is drawn parallel to the picture plane instead of receding (see illustration).

Isometric Projection: Single-view parallel-line projection of an object positioned so that all three principal faces are equally inclined to the drawing surface. There are no true angles in the isometric projection. All other dimensions are true and can be measured. These three planes are constructed at 120 degrees from each other, or at 30 degrees from the horizon line (see illustration).

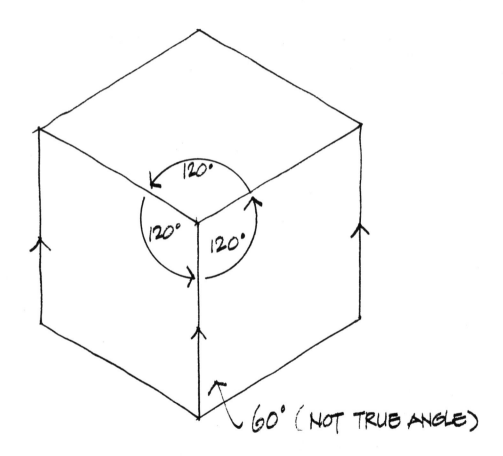

Isometric projection

27

Title: Urban Park Study (II)
Projection: elevation
Medium: color transparencies and thin
black marker

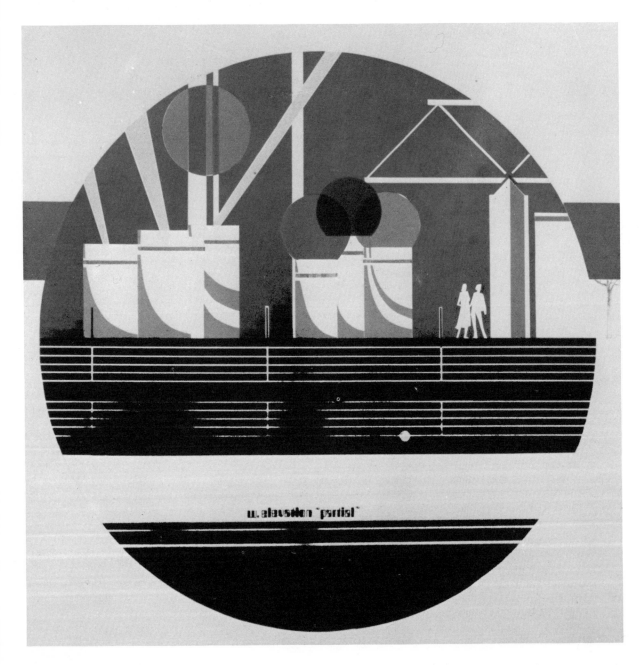

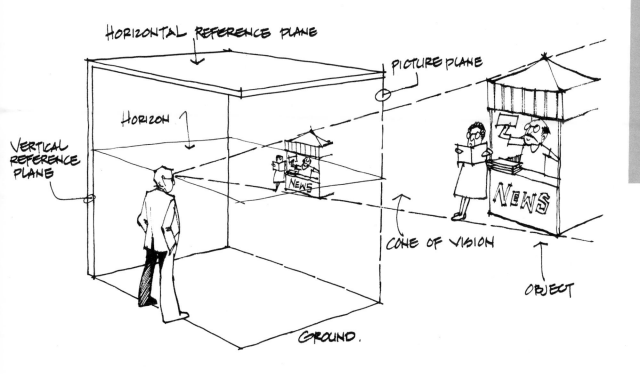

HORIZONTAL REFERENCE PLANE

PICTURE PLANE

HORIZON

VERTICAL REFERENCE PLANE

CONE OF VISION

NEWS

NEWS

OBJECT

GROUND.

Operational procedure of perspective

PERSPECTIVE PROJECTION

1. Definition: A graphic image of a three-dimensional object when the projection lines (rays) all converge at the point of the viewer's eye (see illustration).

2. Features
 a. Perspectives are attempts to present a realistic picture of the design proposal.
 b. There are no true angles or measurements in perspective except those of the frontal planes (i.e., planes that are parallel to the picture plane).
 c. Perspectives produce an illusion of depth.

3. Glossary

Center of Vision: A mythical point between the eyes that is the apex of the cone of vision. It can also be expressed as the shortest distance between the SP and the PP.

Cone of Vision: A mythical reference cone with its apex at the SP and centered at the center of vision; the base on the surface of the picture plane defines the extent of our visual perception.

Horizon Line (H): The major horizontal reference plane; it cuts through the center of vision. It will always appear as a line. Its vertical positions on the picture plane determine the appearance of the perspective.

Object: Structures, landforms, and vegetation. Simple, rectilinear and right-angled bodies are the easiest to represent in the form of perspective drawing.

Picture Plane (PP): A plane that is perpendicular to the cone of vision. Its position relative to the object determines the accuracy of the perspective drawing. Distance form PP to SP determines the size of the picture.

Reference Plane (RP): A plane passing through the center of vision having a definable relationship to something within our environment (i.e., parallel to a wall, floor, planar surface, or line). Floor, roof, and ground are

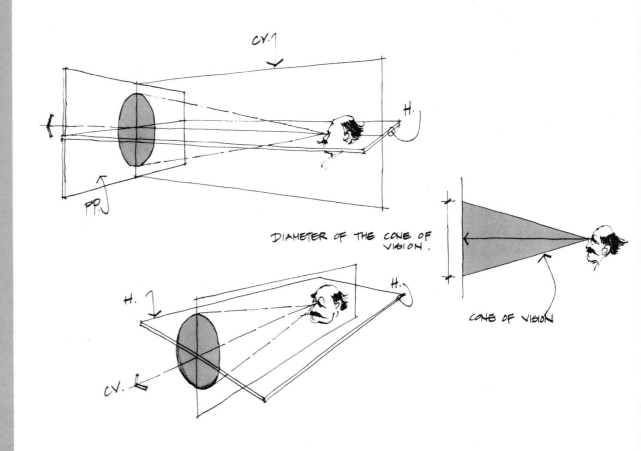

Cone of vision

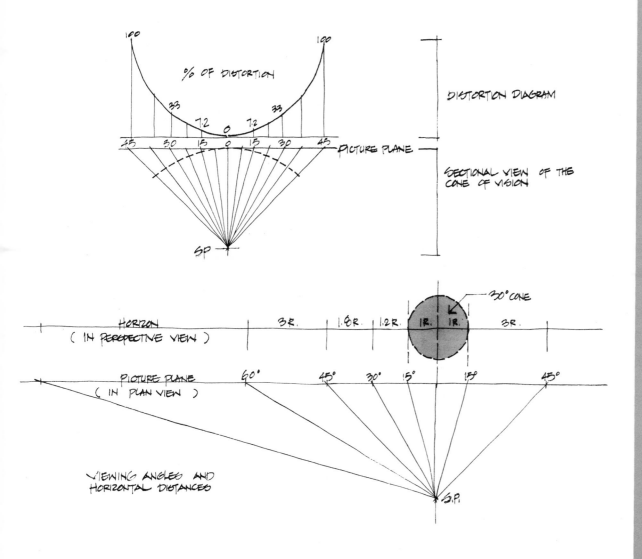

Perspective distortion diagram

defined as horizontal reference planes (HRP). Wall, rows of trees, shrubs are defined as vertical reference planes (VRP).

Station Point (SP): Represents the position of the eye viewing the object, which determines the appearance of the perspective drawing. Vertical positions of the station point in reference to the picture plane determine the type of view of the perspectives: worm's-eye; worm's-eye with toppling verticals; normal; bird's-eye; or bird's-eye with toppling verticals. Horizontal position (distance) of the station point in reference to the picture plane determines the amount of image perception.

30-Degree Constant: In order to understand the rationale of 30-degree constant, one must be familiar with the perspective distortion diagram. The 30-degree constant is set arbitrarily because: it is (1) closer to our actual instantaneous cone of vision, (2) easier to subdivide into modules to determine the vanishing point, and (3) the least distorted cone of vision in reference to the greatest extent of visual perception in the perspectives.

Vanishing Point (VP): A point in perspective where parallel lines vanish. It is established by the intersection of two or more reference plane lines. VP of horizontal lines lie on the horizon.

Eye-level perspective: the horizon is 5 to 6 feet above ground (eye level), the viewer looks straight ahead. This perspective closely resembles normal perceptual experience.

Worm's-eye view: the viewer is low and looks up, the horizon is low and very close to the ground line, and the height of the object is exaggerated. This view is ideal for buildings especially high-rise.

Bird's-eye view: the viewer looks down from above at an oblique viewing angle. This view presents a large area of coverage, which is ideal for land-development schemes.

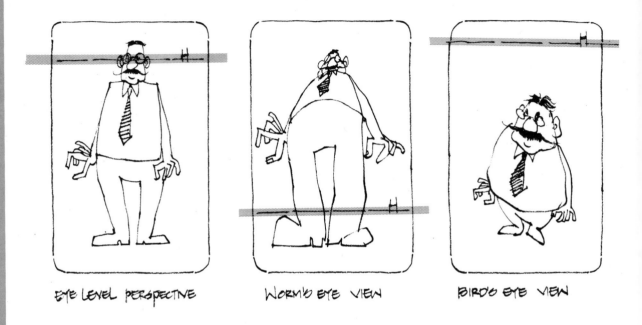

EYE LEVEL PERSPECTIVE WORM'S EYE VIEW BIRD'S EYE VIEW

Location of horizon and the projected image

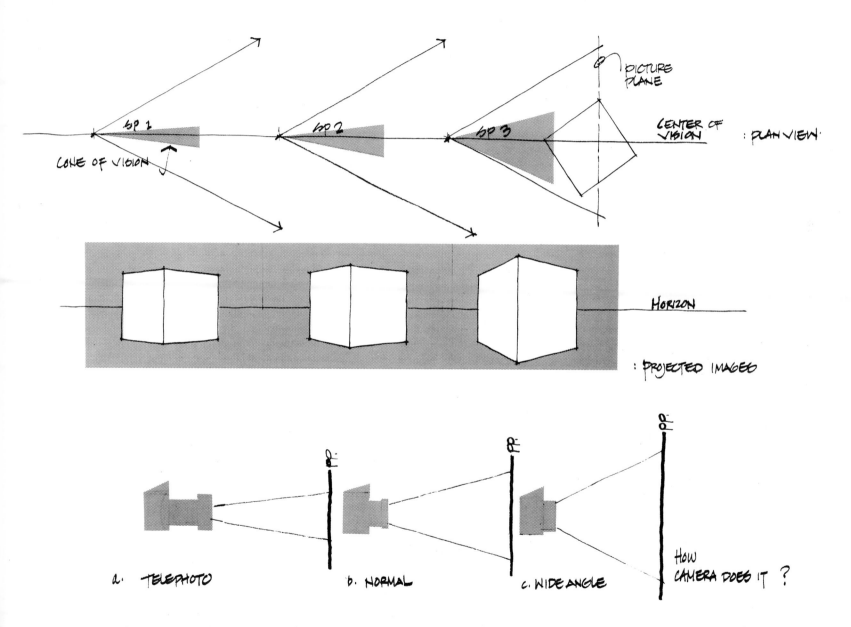

PLAN VIEW

SP 1 SP 2 SP 3

CONE OF VISION

PICTURE PLANE

CENTER OF VISION

PROJECTED IMAGES

HORIZON

a. TELEPHOTO b. NORMAL c. WIDE ANGLE

HOW CAMERA DOES IT ?

Location of station point and the projected image

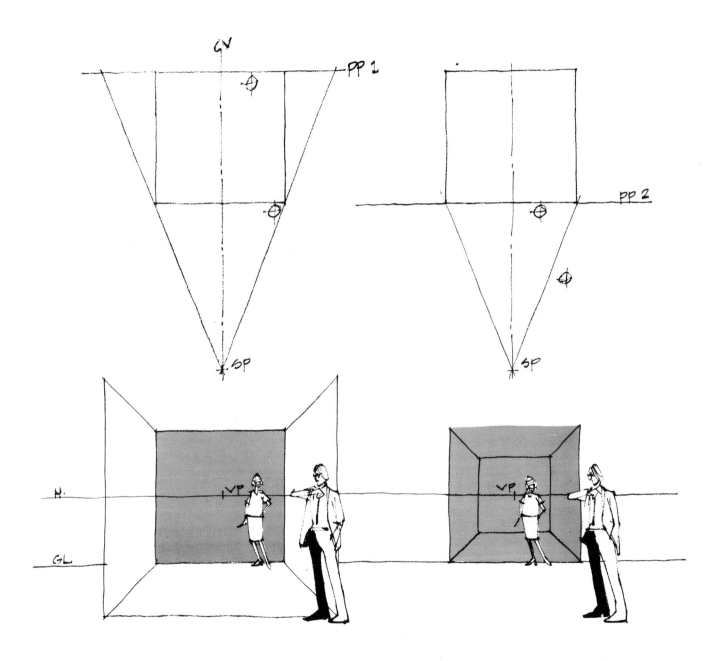

Location of picture plane and the projected image

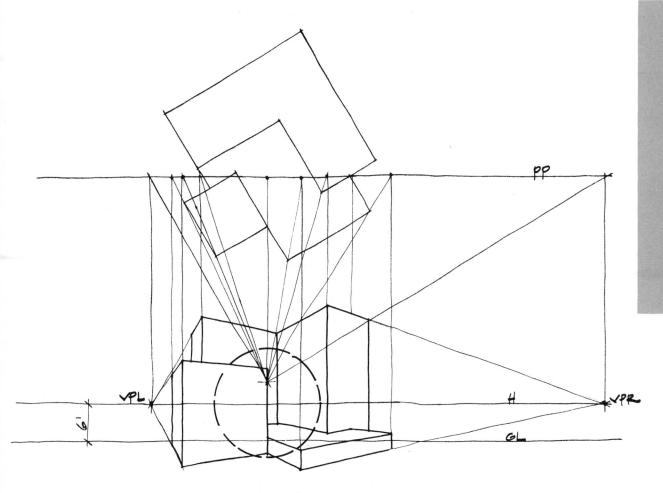

PP

VPL

6'

H

VPR

GL

Eye-level perspective

Relations Between Horizon Line and 30-degree Cone

In this example, two projections are shown to illustrate the differences in horizon line and 30-degree cone.

Example *A* is done as a normal eye-level perspective. Example *B* (see p. 36) is done with the horizon line set at 30 feet above ground.

A 30-degree cone circle is drawn in both perspectives to compare the amount of coverage within the cone and to demonstrate the amount of distortion beyond that of the 30-degree cone.

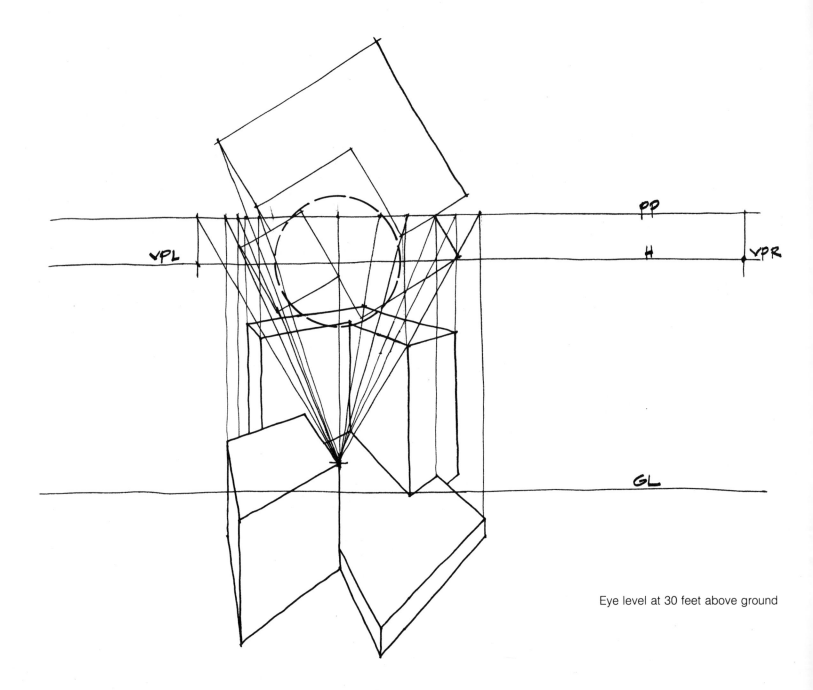

PP

VPL H VPR

GL

Eye level at 30 feet above ground

'A'

'B'

Types of Perspective

A. One-point perspective: the vanishing point is usually at the center of subject.
B. Two-point perspective: the vanishing points usually are located away from the subject.
C. Multipoint perspective: the vanishing points can be anywhere on the horizon line. Multipoint perspective is often conceived as a one-point perspective with two additional vanishing points to each side.

'C'

Plan Projection Method

1. Draw (locate) plan above the view to be plotted; it supplies all horizontal measurements.
2. Use a side view to provide the vertical measurements. These two views must be at right angles to each other.
3. Set up ground line using the ground line of the side view as reference.
4. Locate horizon and plot the vanishing point by dropping the center of vision line down until it intersects the horizon line.
5. Drop dimensions that are on the picture plane perpendicularly; they must be parallel with one another.
6. Draw lines from the side view across the page to intersect the lines dropped from the picture plane.
7. Connect relevant points to create a perspective image.

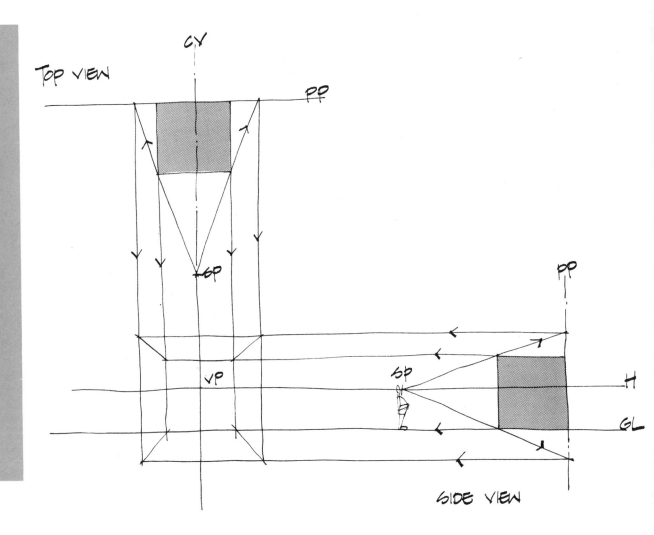

PERSPECTIVE (1-POINT)

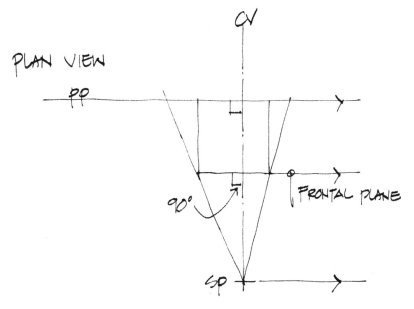

PLAN VIEW

CV

PP

90°

FRONTAL PLANE

SP

FRONTAL PLANE

CV

GL

PP

90°

SP

SIDE VIEW

REFERENCE PLANES

VP

H

1- POINT PERSPECTIVE

Characteristics of One-point Perspective

1. One reference plane must be located frontal to the viewer.
2. Frontal plane should be drawn perpendicular to the center of vision.
3. Frontal plane must be parallel with the picture plane.
4. Vanishing point must be located between the left and right reference planes.
5. Vanishing points must be on the horizon line.

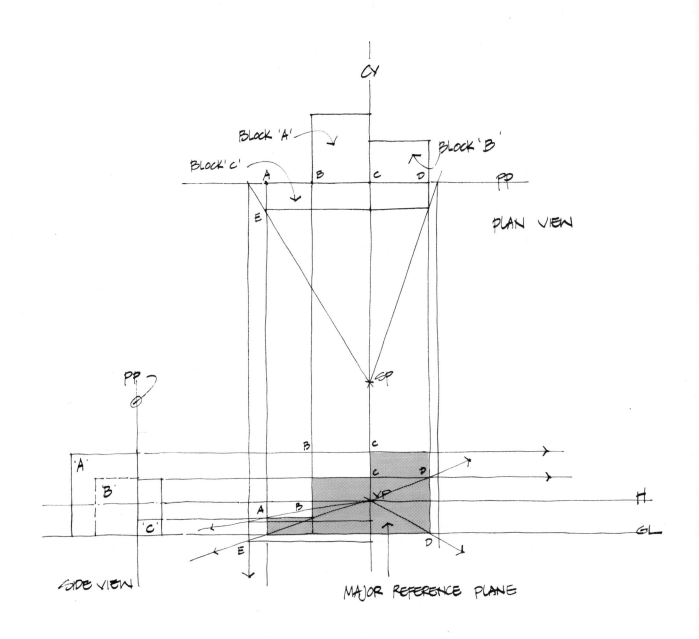

CY

BLOCK 'A'

BLOCK 'C'

BLOCK 'B'

A B C D PP

PLAN VIEW

E

SP

PP

B C

A 'A' C D

'B' VP H

'C' A B

E D GL

SIDE VIEW

MAJOR REFERENCE PLANE

Vertical scale reference plane

40

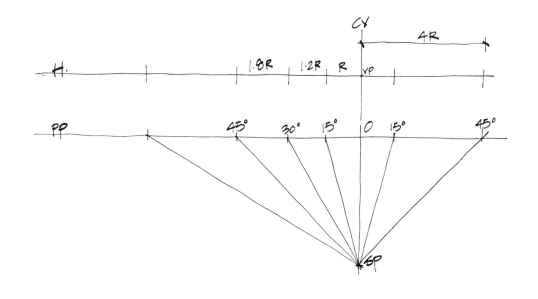

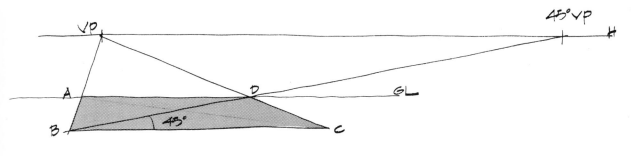

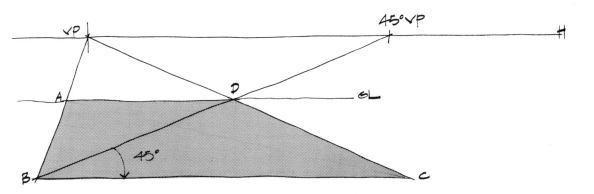

Forty-five-degree Projection

Forty-five-degree projection is used primarily to plot equally spaced receding dimensions on both the horizontal and vertical planes. These include pavement patterns, tree planting, windows, wall treatment, and columns.

The 45-degree vanishing point exists within all one-point and two-point perspectives. It is a built-in device on the horizon line. This point can be located by connecting diagonally a perspective view of a known square and projecting this diagonal line until it intersects the horizon line. There are by nature two 45-degree vanishing points—one at each side from the center vanishing point. These points are used to transfer a known dimension from a true measure axis (frontal) to a nonfrontal (receding) axis (see p. 42).

41

Establishing a 45-degree Vanishing Point

1. Establish VP on horizon.
2. Locate points B and C on GL.
3. Locate points A and D by projecting points PA and PD down from the PP.
4. Finish square ABCD.
5. Connect BD and extend it toward the horizon.
6. Locate right 45-degree VP.
7. Locate points Y and Z on GL.
8. Project points Y and Z back to VP.
9 Locate points F and G.
10. Draw three parallel lines from E, F, and G.

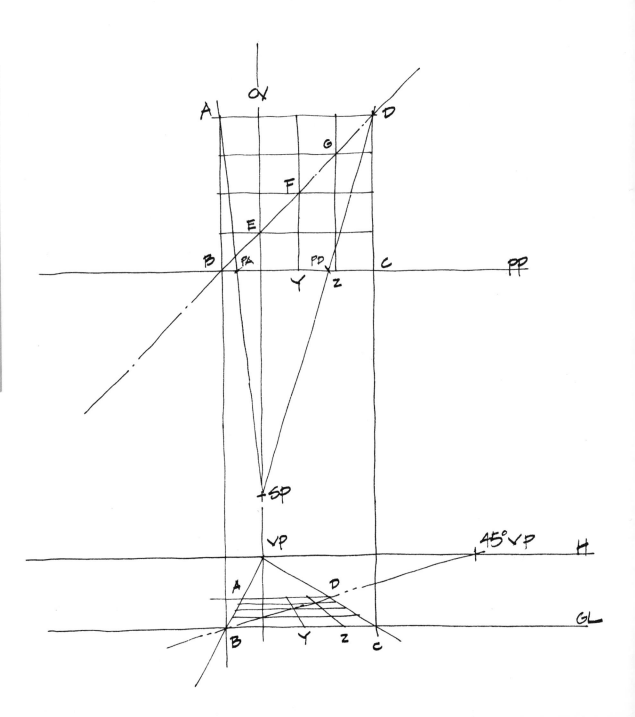

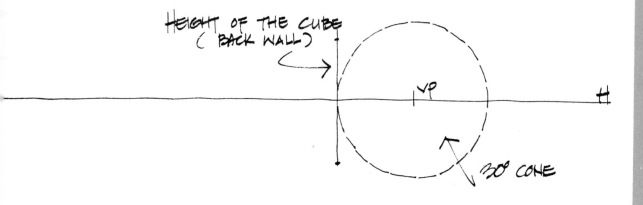

HEIGHT OF THE CUBE
(BACK WALL)

VP

30° CONE

H

Example

This is a step-by-step illustration of
how to construct a perspective view
of an open-face cube from one clue
(the height of the cube) using the 45-
degree projection system.
1. Determine the distance of R by a
 divider.
2. Use the given height to complete
 the rear wall.

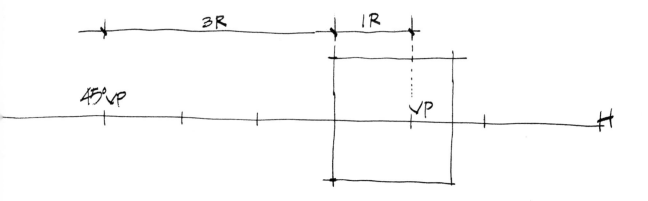

3R 1R

45° VP VP H

43

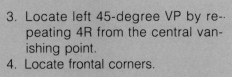

3. Locate left 45-degree VP by repeating 4R from the central vanishing point.
4. Locate frontal corners.

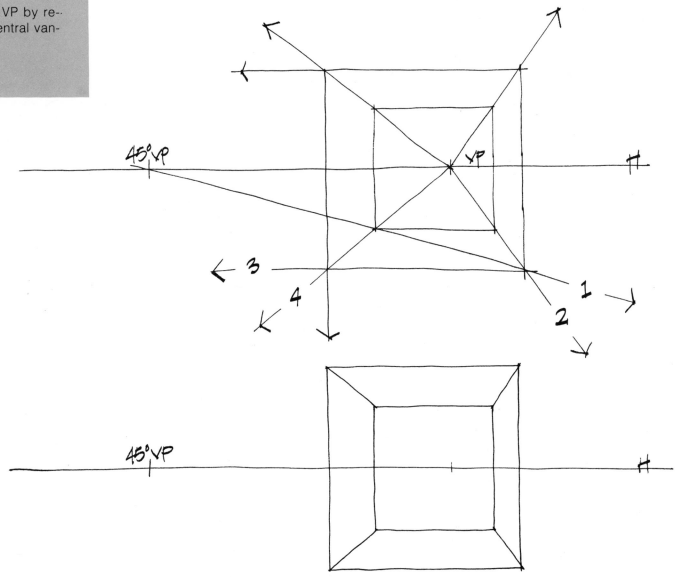

CASE 1 : BOX

CASE 2 : BOX WITH DOOR REMOVED

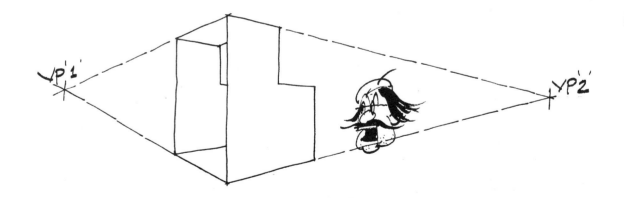

CASE 3 : 2-POINT PERSPECTIVE

Two-point Perspective

Case One
front elevation
box enclosed
only one plane is known

Case Two
one-point perspective
frontal plane and interval organization
 are known

Case Three
two-point perspective
two planes are known
depth shown
hidden information on the back wall
 shown

Two-point Perspective

1. All lines or planes that are parallel with plane A vanish to VP 2.
2. All lines or planes that are parallel with plane B vanish to VP 2.
3. The top plane is hidden when the horizon is lower than the height of the object.
4 The top is visible when the horizon is raised above the highest point of the object.

Two-point perspective: example A

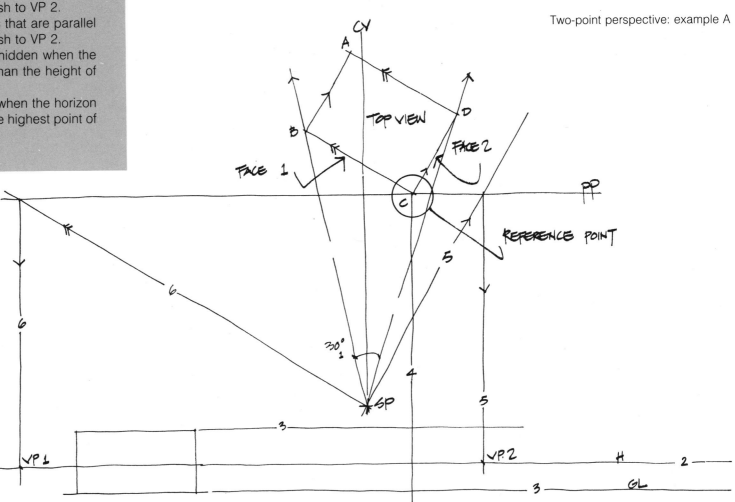

Two-point perspective: example B

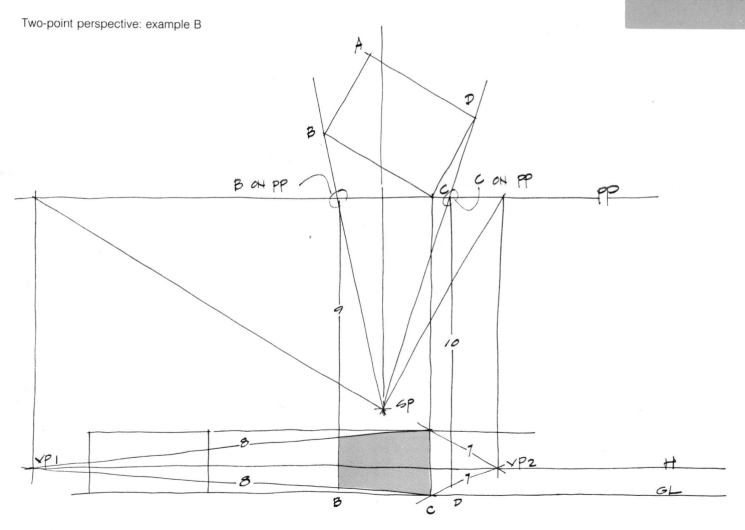

47

Three-point Perspective

This figure illustrates the limitation of the one-point perspective. Because of the nature of the frontal plane (perpendicular to the center of vision), images that are away from the center can become highly distorted on the perspective projection. This, of course, can be resolved by significantly dropping the SP away from the picture plane, thus ensuring that the entire picture will be covered within the 30-degree cone. Yet, we sometimes must give up this inconvenient process and live with some form of distortion for the sake of practicality.

48

Three-point perspective: example

In order to minimize the frontal plane distortion, the flatness of the frontal plane is broken up and subdivided in several vertical sections. This creates a slight curvature on the frontal plane and produces a visual sensation much like viewing through an ultra-wide-angle lens. Because of the sectional planes, and the angles they face, new vanishing points must be introduced for each plane, thus creating a so-called multi-vanishing-point projection. It is used more for visual effect than to accurately portray the substance (see p. 55).

TO VPL

TO VP'R

VP

H

GL

Title: Streetscene (rough sketch)
Projection: two-point
Medium: pencil

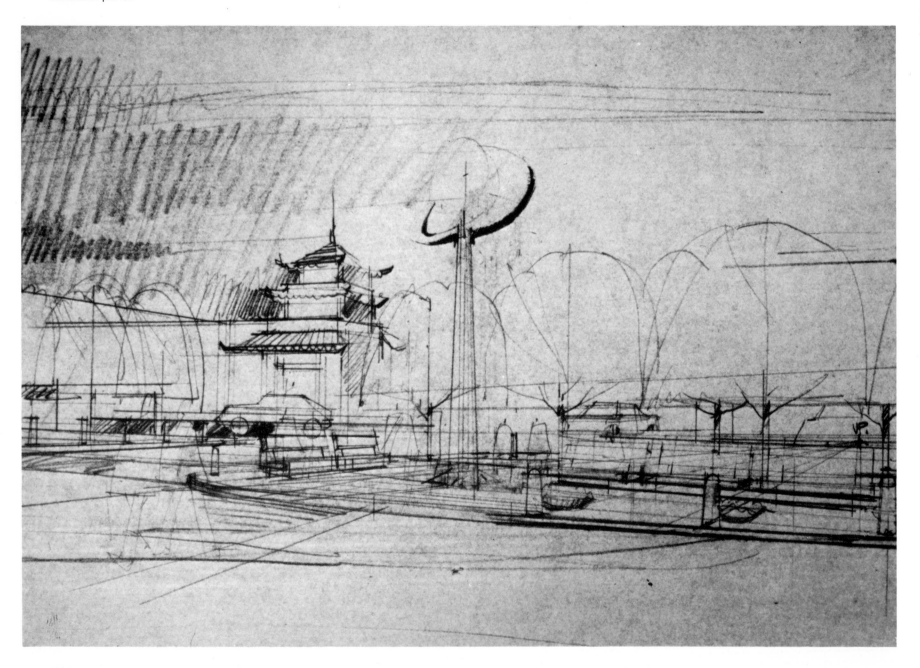

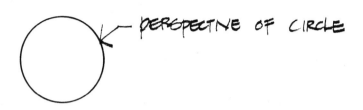

PERSPECTIVE OF CIRCLE

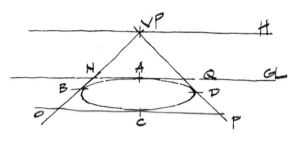

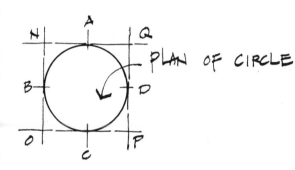

PLAN OF CIRCLE

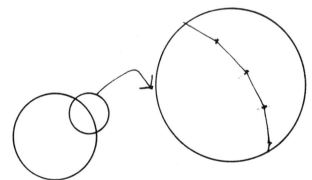

Circle in Perspective

1. A circle exists within a square plane.
2. A circle can be plotted with a minimum of four tangents (see illustration).
3. All curved lines are formed by connecting short dashes.
4. The smoothness of the curvature is governed by the number of short dashes.
5. The locations of lines are determined by points.
6. A construction of a circle perspective must begin with the plotting of points along the circumference.

The following illustrations outline the step-by-step construction process of a circular pattern within a square box on the ground plane. A 30-degree cone is used to establish the frontal dimension of the square (NO) and the R by dividing line NO into two equal sections.

Forty-five-degree projection is used to locate the two back corners of square NOPQ.

A rough plan view is placed directly above the perspective plot to find the thickness of the square pattern (N, NG). This can also be done with a scale or with a divider. In addition to the four tangent points, four reference points (R,T) are required to produce a better-looking area. Step one presents the procedure for obtaining these points.

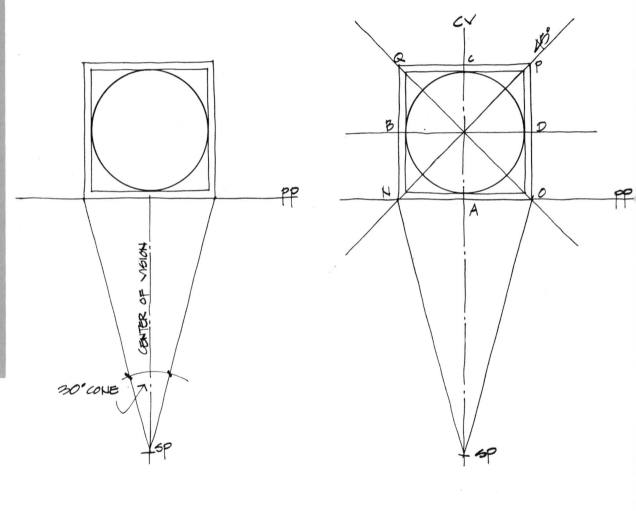

Plan view

Step one

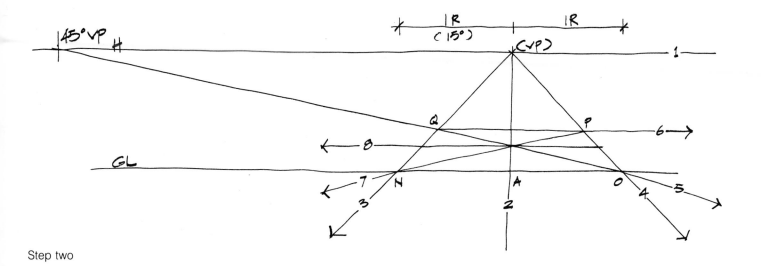

Step two

53

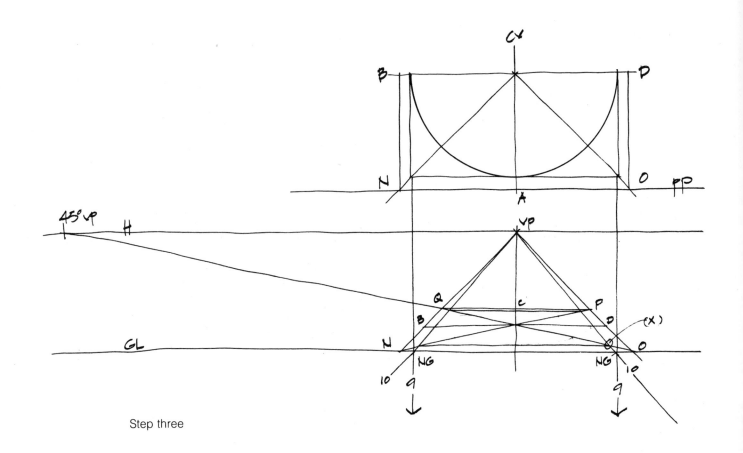

Step three

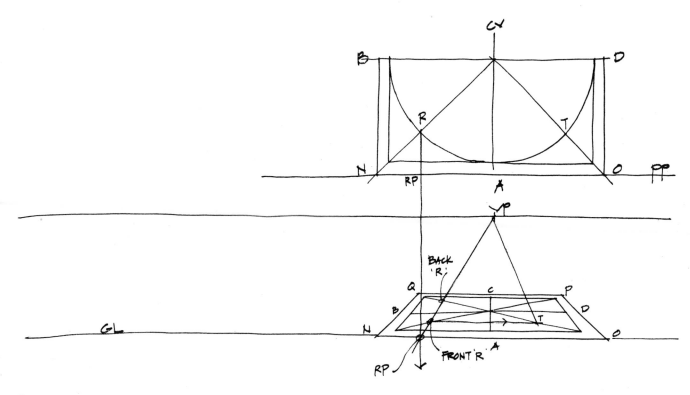

Step four

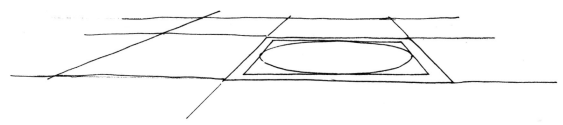

Pattern in perspective

Shades and Shadows in Perspective

The depiction of shades and shadows not only enhances the appearance of the perspective but also amplifies the sensation of depth in these drawings. Determining their placement and rendering them in turn enable the designer to visualize his design object better.

Shadow occurs when the sun's rays (or other source of light) are interrupted. When an object is placed in front of the light source, the interruption causes the object to cast its own shadow.

The sun's rays are parallel. The length of a shadow is determined by the height of the object and the altitude of the sun. The direction of a shadow is determined by the bearing of the sun.

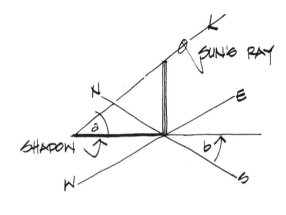

Operating procedure of shadow

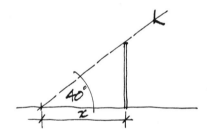
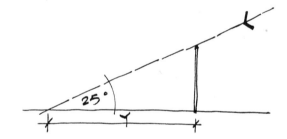

Sun's altitude and length of shadow

Sun's bearing and direction of shadow

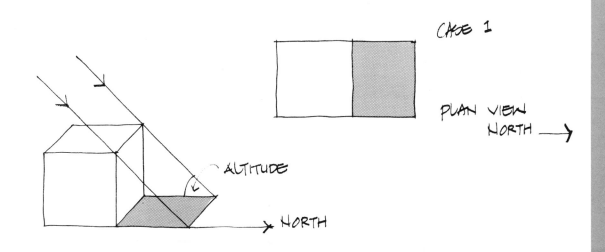

CASE 1

ALTITUDE

NORTH

PLAN VIEW
NORTH →

Case One
sun's rays parallel to the edges of the
 object
shadow parallel to the edges of the
 object

Case Two
sun's rays not parallel to the edges of
 the object
shadow parallel to the edges of the
 object
 All lines in shadow must be treated
in sets of parallel lines and should
therefore follow all perspective con-
struction principles. Shadow has its
own vanishing point.

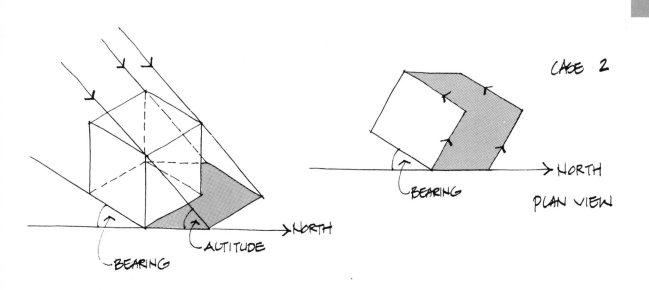

CASE 2

BEARING

ALTITUDE

NORTH

BEARING

NORTH

PLAN VIEW

Grouping of Parallel Lines in Perspective

	In Object	In Shadow
Set A	FE, GH, AD, BC	SF—SE (Cast by FE)
Set B	ED, HC, FA, GB	SF—SA (cast by FA)
Set C		SA—B SE—H (cast by AB and HE)

Set A vanishes to VP 1.
Set B vanishes to VP 2.
Set C vanishes to shadow vanishing point.

In one-point perspective, either Set A or Set B will be governed by one vanishing point. The other set of lines should be parallel with the picture plane.

In this diagram line B, A, F, E, H will cast shadow. The corresponding shadow is B, SA, SF, SE, H.

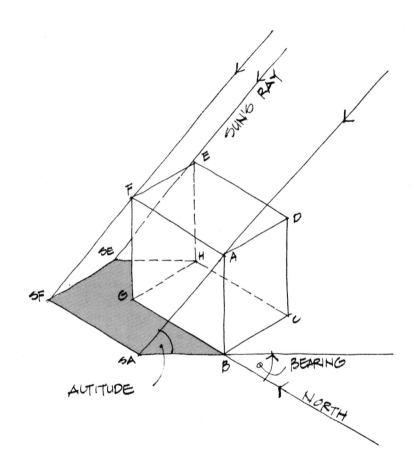

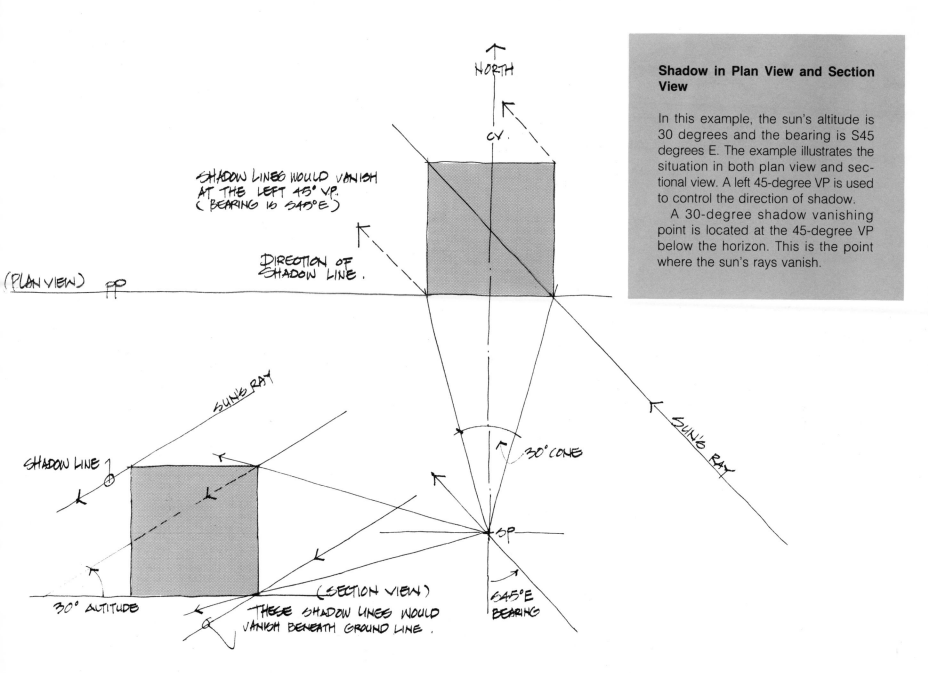

NORTH

CV.

SHADOW LINES WOULD VANISH
AT THE LEFT 45° V.P.
(BEARING IS S45°E)

DIRECTION OF
SHADOW LINE .

(PLAN VIEW) PP

SUN'S RAY

30° CONE

SUN'S RAY

SHADOW LINE

SP

30° ALTITUDE

(SECTION VIEW)

THESE SHADOW LINES WOULD
VANISH BENEATH GROUND LINE .

S45°E
BEARING

Shadow in Plan View and Section View

In this example, the sun's altitude is 30 degrees and the bearing is S45 degrees E. The example illustrates the situation in both plan view and sectional view. A left 45-degree VP is used to control the direction of shadow.

A 30-degree shadow vanishing point is located at the 45-degree VP below the horizon. This is the point where the sun's rays vanish.

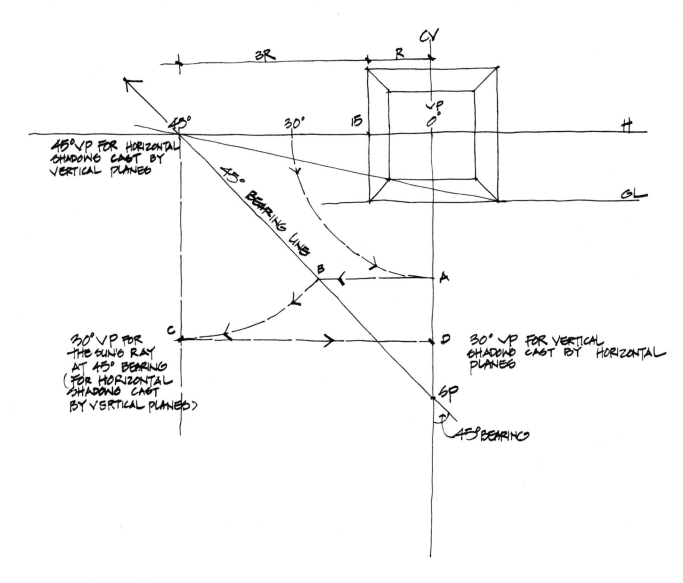

Shadow in perspective. Step one

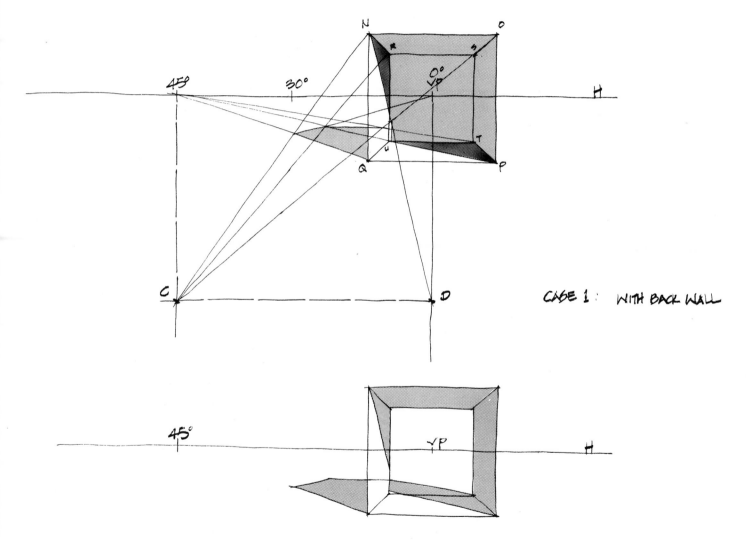

CASE 1 : WITH BACK WALL

CASE 2 : WITHOUT BACK WALL

Step two

Title: Streetscene
Perspective: one-point
Medium: color markers on marker paper

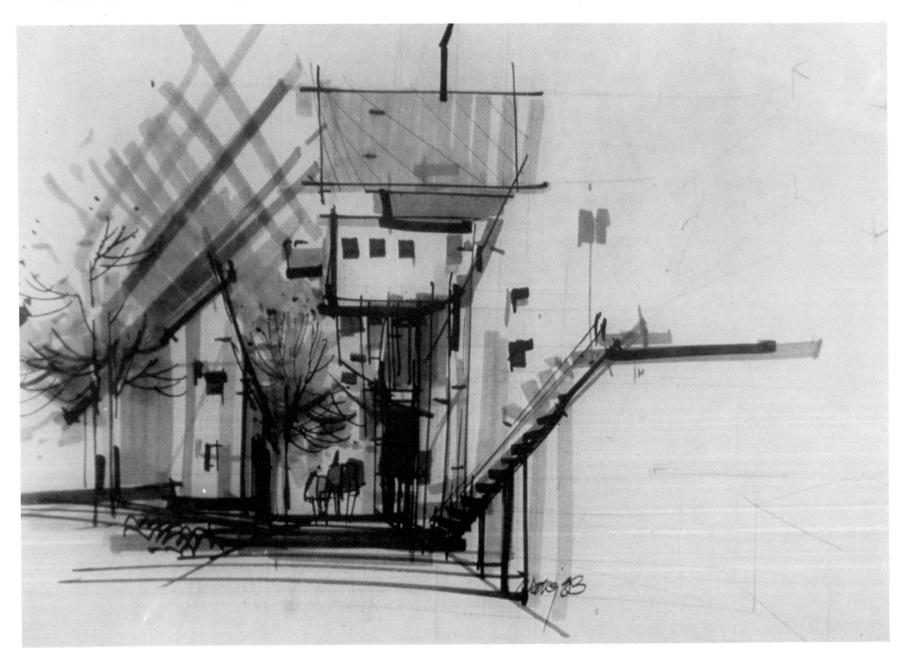

The eyes as judge

PERSPECTIVE DRAWING

Having dealt with some technical aspects of parallel line and perspective projection, the second portion of this book will be devoted to the art of drawing. As stated earlier, I don't differentiate technical information from nontechnical information when discussing the application of these projection principles.

The Eyes

The most crucial aspect in successful design drawing is the ability to judge accuracy without relying on any measuring devices except one's own eyes. Accuracy refers to dimensions as well as the direction of lines. In parallel line projections, this visual judgment is used to determine the length of lines, the consistency of all parallel lines, and the accuracy of all angles. Since most dimensions and angles will be known prior to the execution, this drawing task is a literal transfer of information. Because there is no foreshortening effect or diminishing of size in these projections, the task is much easier than that in perspective projections.

Most lines of perspective projections are not drawn parallel to one another. There are no true angles, nor are there any true measurements. The only exception occurs on the frontal plane. The accuracy and effect of perspective must be attained via a "comparative" visual judging method. The artist must be able to recall certain realistic effects (such as repetition of equally spaced columns) and compare them with the drawing under execution. Constant adjustment must be made to ensure the correct effect (e.g., depth and height transition) in the drawing. The interaction between the drawing and the eyes is very important in this sketching process and the designer must be capable of making these visual decisions.

The drawing/seeing process

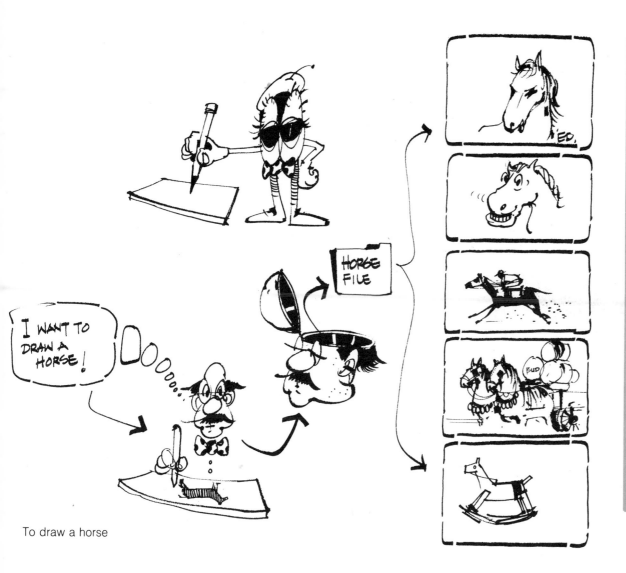

To draw a horse

The ability to "sketch" with one's eyes is not easily learned, and one cannot simply rely on the understanding of mathematical information. Drawing is merely a recollection and rearrangement of previously seen images. These pictorial images are literally stored in one's mind, awaiting recollection. These images are mostly stored in perspective form, and the effects of perspective are vividly recorded. During recall, images can either be transferred directly onto the paper or be freely altered and rotated according to the desire of the designer to achieve a certain effect. For example, when drawing a perspective of a house, the designer may have seen only the plan and elevations of the structure. The transformation from parallel line projections to perspective is done mentally and graphically. The record on paper is a result of the active interaction of the eyes, the brain, and the hands. It is the eyes that ultimately make the judgment.

Most drawing failures are not due to the artist's inability to draw, but to the lack of images to recall. Even on-site sketching can be classified as an instant recall process. There are no suitable images to be recalled because casual observation never leaves substantial amounts of perceptual memories. A designer must learn and practice to see keenly and sharply, so he will remember. The picture in front must be absorbed and recorded. The designer must notice the total contrast, the subtle color effects, the details, the changes in depth, and the relative sizes in components within a composition. A good visual memory is the key to a good drawing and a keen eye is a prerequisite for a good visual memory.

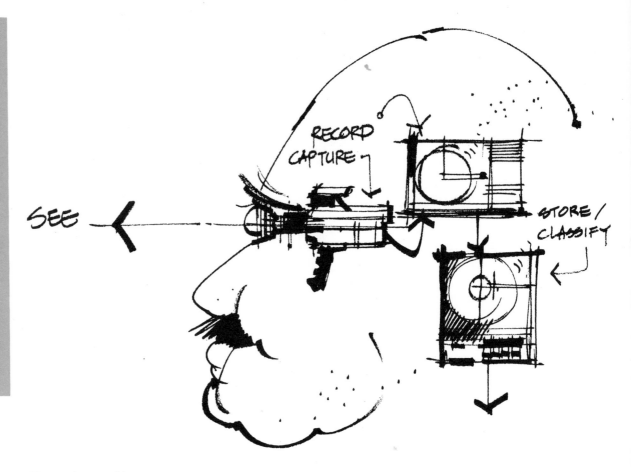

The seeing machine

The Drawing Process

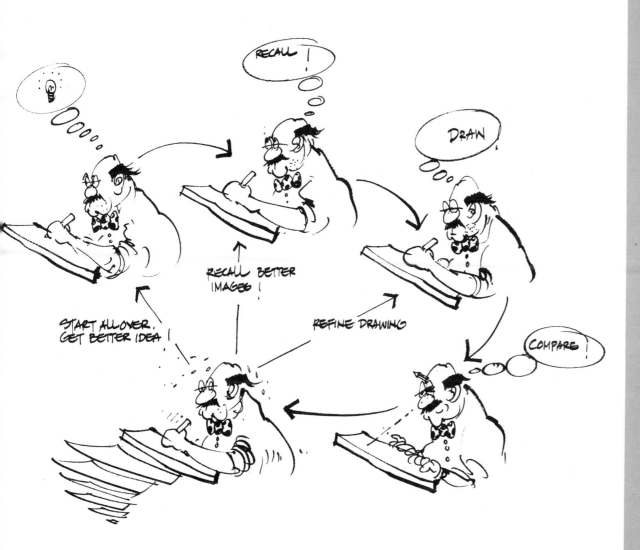

RECALL!

DRAW.

RECALL BETTER IMAGES!

REFINE DRAWING

COMPARE!

START ALL OVER. GET BETTER IDEA!

The following discussion of the drawing process is concerned mostly with perspective projection because of its wide range of uses. In order to construct perspective drawing in an un-inhibited way, one must first understand the principles of perspective construction, and then acquaint himself with the various drawing techniques, specifically those related to hand/arm movement.

As previously discussed, perspective principles are based on mathematics and are therefore rather straightforward. These methods of perspective construction can be systematically traced and plotted and the procedures are in general quite easy to understand. One must bear in mind that these methods are only ways to simulate the functions of our eyes and that many other methods are also available. These pictorial representations are recorded in a way similar to that of a camera taking photographs. Instead of rendering on film, perspectives are drawn on paper. Both have a single viewing point, and the surface of the projections are all flat. Our eyes have binocular vision and can therefore sense depth. A stereo visual effect can only be achieved through stereo photography or simulated through the curved-picture-plane perspective, which involves a series of consecutive station-points along the same horizon. This special perspective is not com-

monly used and is not as important as the traditional one-point or two-point drawings. After all, perspectives are illusions and are meant to fool people visually. Perspective drawing produces a recordable visual sensation that best resembles the way our eyes see. It helps you visualize the design proposal; helps identify problem areas and seek ways to improve them; and above all, exercises your visual thinking mechanisms and sharpens your design skill. It is this last item which makes drawing perspectives an enjoyable task. It is not the tedious effort, but the fun of tracking ideas and drawing what you think that make perspective drawing unique.

Title: Railroad Station, Kalamazoo, Michigan
Projection: one-point
Medium: color marker on yellow tracing paper

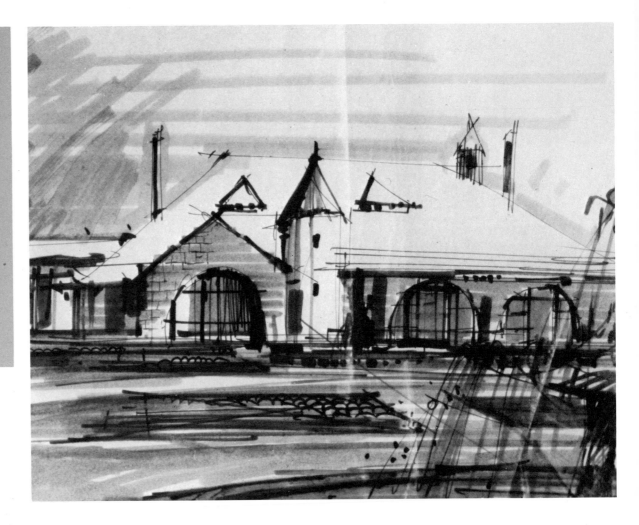

Arm Movement

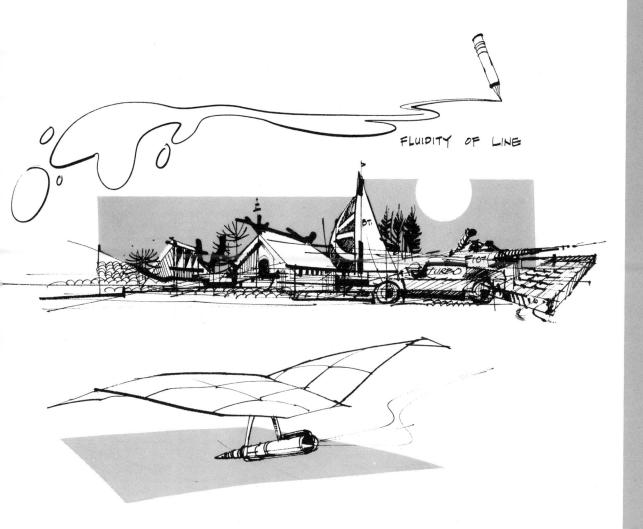

FLUIDITY OF LINE

To draw, one must know how to move the arm and hand. The quality of a drawing is not just a matter of accuracy, it must come from the expression of lines and textures. Line quality must be fluid and expressive. It must connect planes and define spatial edges. It represents materials and sizes of all dimensions. Regardless of drawing medium, all lines must be drawn as if they are gliding freely across the sheet. They must begin and stop, expand and contract, in the correct places. Even though the commands come from the brain, the hands must ultimately perform the task of drawing. Realism and accuracy are constantly judged by the eyes, and the cycle of eyes, mind, and eyes is therefore nonstop.

The hand must be willing to follow the commands. It must act immediately on impulse. It must move swiftly without interruption. Often, our minds function faster than our hands and it is very difficult for the hands to catch up. Our minds conceive design solutions; recall and rearrange images; make up new ones; and determine new placement. The hand must respond quickly and draw these decisions as soon as they are made; this allows the eyes to make judgments in seconds. Rapid hand movement not only improves the ability to track one's thoughts but most importantly of all, it sharpens the functions of our eyes.

ALWAYS EXTEND ARM
MOVEMENT BEYOND THE
SHEET BORDER.

90°

YOU

ALWAYS SIT PERPENDICULAR
TO THE EDGE OF TABLE (OR
EDGE OF SHEET.)
KEEP TABLE TOP CLEAN.
WASH HAND BEFORE DRAWING
KEEP PALM ABOVE PAPER.

KEEP BODY UPRIGHT!
DON'T BEND OVER.
EXTEND ARM WHEN REACHING TOP.

SLIGHT INCLINE

Sheet Size

In order to facilitate rapid and precise hand movement, we must work with larger sheet sizes. The ideal sheet size is 24 by 16 inches. It is an optimal format because our arms can travel freely horizontally and vertically without overextensions. Designers must avoid working with small paper formats (8½ by 11 inches or smaller) because they not only result in small pictures but inhibit the movement of the arms.

The Wrist

Drawing must be controlled by the combination of arm and hand. The wrist must be flexible to allow quick lockage. Horizontal lines especially, must be drawn with the arm extended and the wrist locked. Excessive wrist action produces arcs and curved lines. It also makes drawing of long horizontal strokes impossible. Use the entire arm when you are drawing. Lift the hand off the paper and control the entire movement with your forearm. Hand and finger movement should be minimized except during shading or detailing.

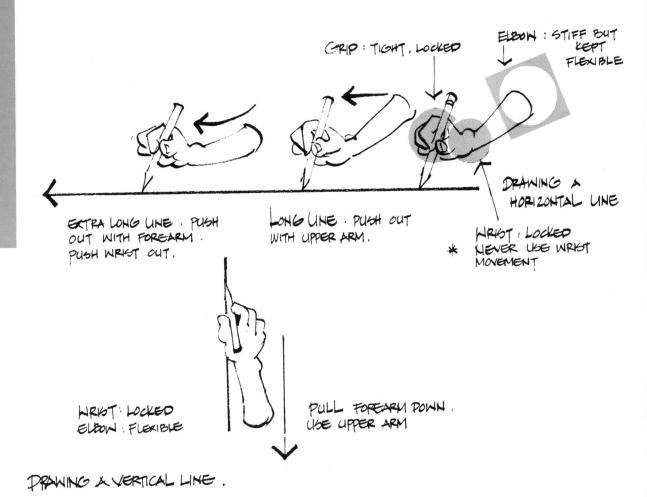

GRIP : TIGHT . LOCKED

ELBOW : STIFF BUT KEPT FLEXIBLE

DRAWING A HORIZONTAL LINE

EXTRA LONG LINE . PUSH OUT WITH FOREARM . PUSH WRIST OUT .

LONG LINE . PUSH OUT WITH UPPER ARM .

WRIST : LOCKED . NEVER USE WRIST MOVEMENT

WRIST : LOCKED ELBOW : FLEXIBLE

PULL FOREARM DOWN . USE UPPER ARM

DRAWING A VERTICAL LINE .

Eye-Hand Coordination

In order to achieve precision, line direction must be controlled. The line destination should be known prior to the execution of each line. Fix your eyes on the destination instead of looking at the point of the moving pencil. An internal sensing device will automatically guide the pencil to its destination. Movement across the page should be swift and crisp.

STEP B. PULL ACROSS THE PAGE.
TRUST YOUR COORDINATION.
DON'T HESITATE.
DON'T STOP HALF WAY

STEP A : FOCUS ON DESTINATION.
PUT PEN ON STARTING POINT.
RELAX. DON'T PANIC

Setup of a Drawing

Always draw a line longer than its pre-scribed dimension. Use your eyes or a scaling device to make the dimension desired afterward. Sometimes it is better to draw a group of lines, such as the projection rays, before dimension trimming. This gives the picture a better proportion and fits the sheet size more appropriately.

Drawing is an art and should never be done mechanically. Though at times it is necessary to rely on some scaling devices for accurate measurement, freehand drawing is still preferable. The eyes therefore play a critical role. Essentially, your eyes do most of the drawing.

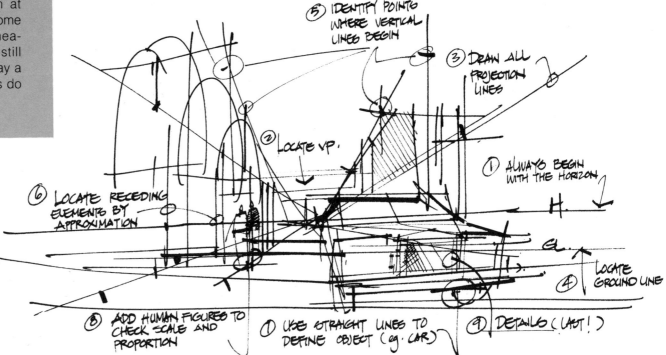

⑤ IDENTIFY POINTS WHERE VERTICAL LINES BEGIN

③ DRAW ALL PROJECTION LINES

② LOCATE VP.

① ALWAYS BEGIN WITH THE HORIZON.

H.

⑥ LOCATE RECEDING ELEMENTS BY APPROXIMATION

G.L.

④ LOCATE GROUND LINE

⑧ ADD HUMAN FIGURES TO CHECK SCALE AND PROPORTION

⑦ USE STRAIGHT LINES TO DEFINE OBJECT (eg. CAR)

⑨ DETAILS (LAST!)

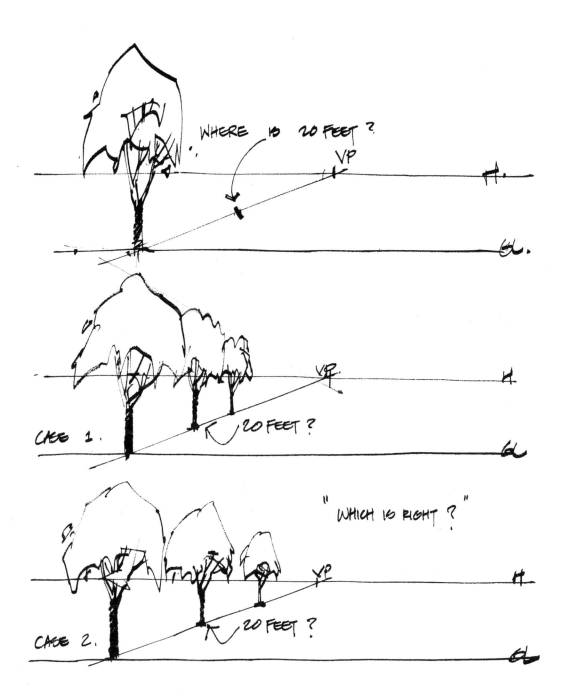

WHERE IS 20 FEET?

VP

H.

6L.

CASE 1.

VP.

20 FEET?

H

6L

"WHICH IS RIGHT?"

CASE 2.

VP

20 FEET?

H

6L

FREEHAND DRAWING TECHNIQUES

The most difficult task among all in the freehand perspective construction method is to predict the horizontal depth. Obviously, this receding distance can be easily obtained by means of plan projection (see p. 38). Yet, in the freehand method, these distances must be visually determined to create a sense of "felt" accuracy in order to produce a proportionally balanced picture.

The two methods presented are neither new nor difficult. They are technically classified as plan projections because the key elements in these methods are all derived from plan projection. Understanding the operation of plan projection allows one to move beyond all the traditional procedures. It enables one to bypass the necessity of using the plan as a fundamental setup. Plan becomes an indirect reference, and the perspective can be drawn without the direct scale control from the plan and section. One can set up the perspective drawing at any desired scale and the vertical viewing angle can easily be changed by adjusting the height of the horizon.

Bear in mind that there are no mysteries in these methods. Eyeballing is not a new and different perspective construction method. It is simply a stage beyond familiarity with the method, and the keyword here is practice.

In short, you ought to be able to draw perspective faster and with confidence after knowing the essence of the mathematical procedure. The effectiveness of shortcuts lies in your willingness to explore.

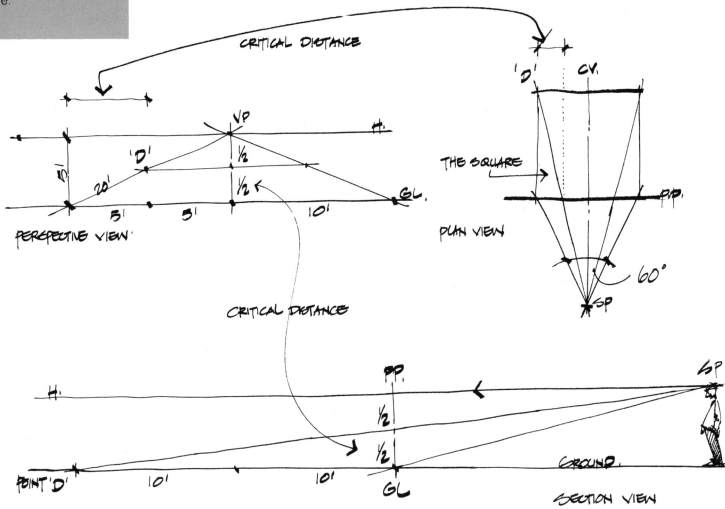

CRITICAL DISTANCE

'D' CV.

THE SQUARE

PLAN VIEW

P.P.

60°

SP

VP

H.

'D'

½
½

GL.

20' 5' 5' 10'

PERSPECTIVE VIEW

CRITICAL DISTANCE

PP.

SP

H.

½
½

GROUND.

POINT 'D' 10' 10' GL

SECTION VIEW

METHOD B: ⅓ EYELEVEL

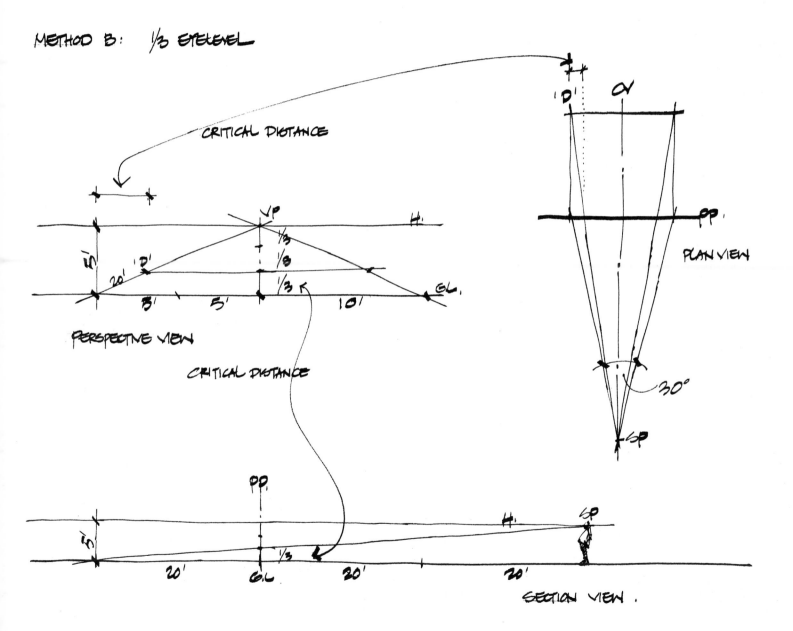

CRITICAL DISTANCE

VP

H'

⅓
⅓
⅓

5'

20' D'

5' 5' 10' GL

PERSPECTIVE VIEW

CRITICAL DISTANCE

α

D'

PP

PLAN VIEW

30°

SP

PP

5'

H' SP

⅓

20' GL 20' 20'

SECTION VIEW.

Comparison of Methods A and B

The major difference between these two methods is the coverage of the cone of vision. Method A (see p. 76) employs a 60-degree cone, whereas Method B uses a 30-degree cone (see p. 77). As stated already, the cone of vision determines not only the coverage of the drawing, but also governs the amount of perspective distortion that a drawing can tolerate.

With a greater cone of vision, the receding dimensions diminish a lot more quickly and thus exaggerate the transition of its actual depth. This may indeed come closest to the way we see, but when it is projected on a two-dimensional drawing surface, the sensation one gets when seeing it is quite different from when viewing the real scene. In this instance, the feeling truly overrides the intellectual understanding.

On the other hand, a drawing that uses a 30-degree cone of vision resembles a picture taken with a telephoto lens. It has a slower convergence rate and the depth transition is a lot more gradual. This somewhat flat look is due to the distant station point, which is almost twice as far as that used in the 60-degree cone. The drawing is therefore more appealing to the eyes.

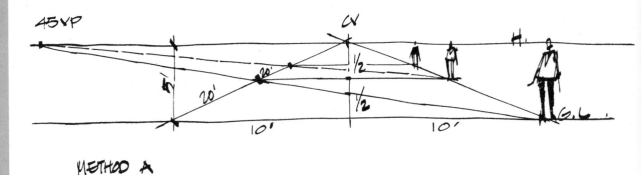

METHOD A

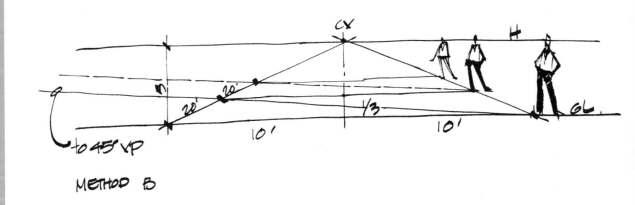

METHOD B

DIVIDE A LINE INTO TWO EQUAL DISTANCES

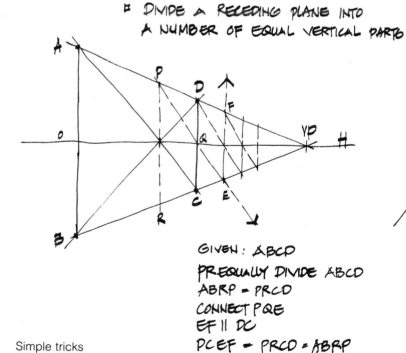

A B

ARC

CENTER

DIVIDE A KNOWN DISTANCE INTO EQUAL PARTS

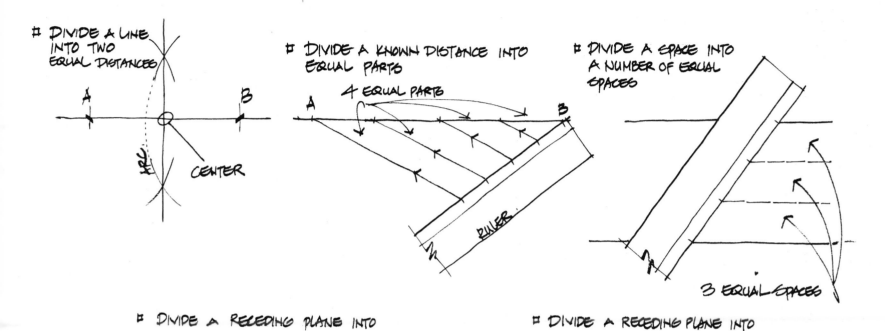

4 EQUAL PARTS

A B

RULER

DIVIDE A SPACE INTO A NUMBER OF EQUAL SPACES

3 EQUAL SPACES

DIVIDE A RECEDING PLANE INTO A NUMBER OF EQUAL VERTICAL PARTS

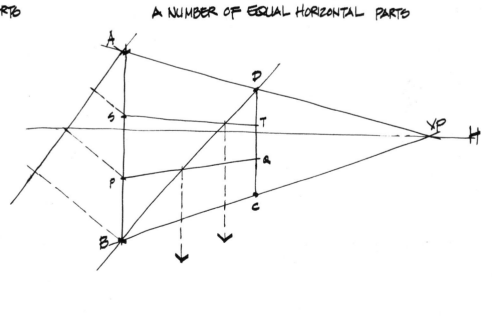

GIVEN: ABCD
PREQUALLY DIVIDE ABCD
ABRP = PRCD
CONNECT PQE
EF ‖ DC
PCEF = PRCD = ABRP

DIVIDE A RECEDING PLANE INTO A NUMBER OF EQUAL HORIZONTAL PARTS

Simple tricks

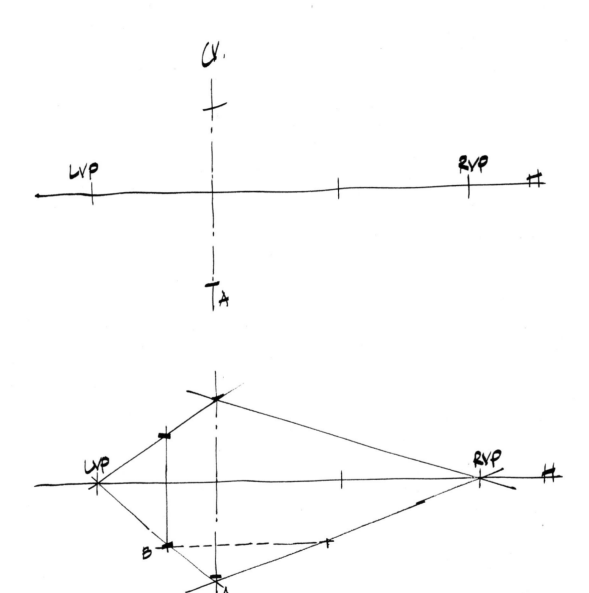

Depth prediction in two-point perspective (A)

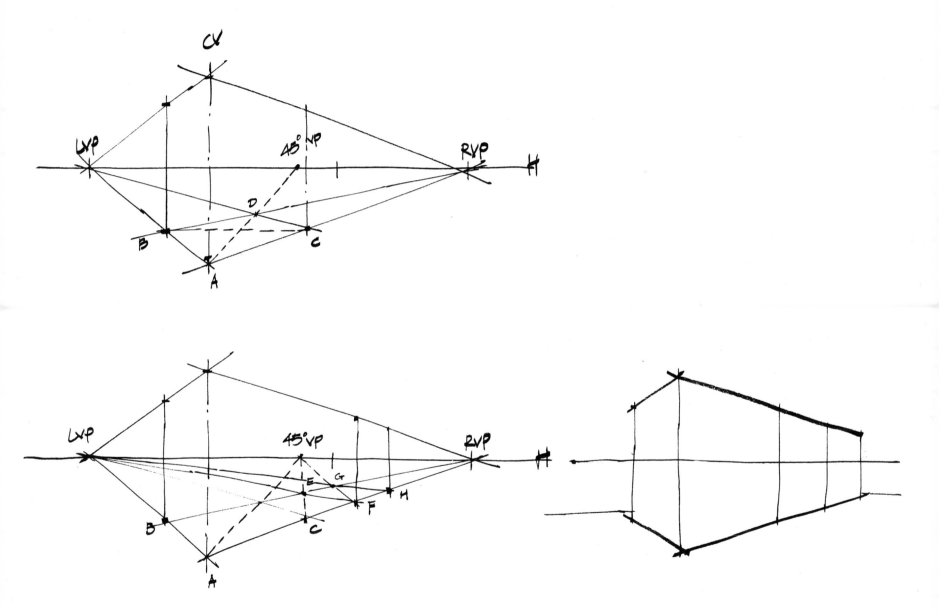

Depth prediction in two-point perspective (B)

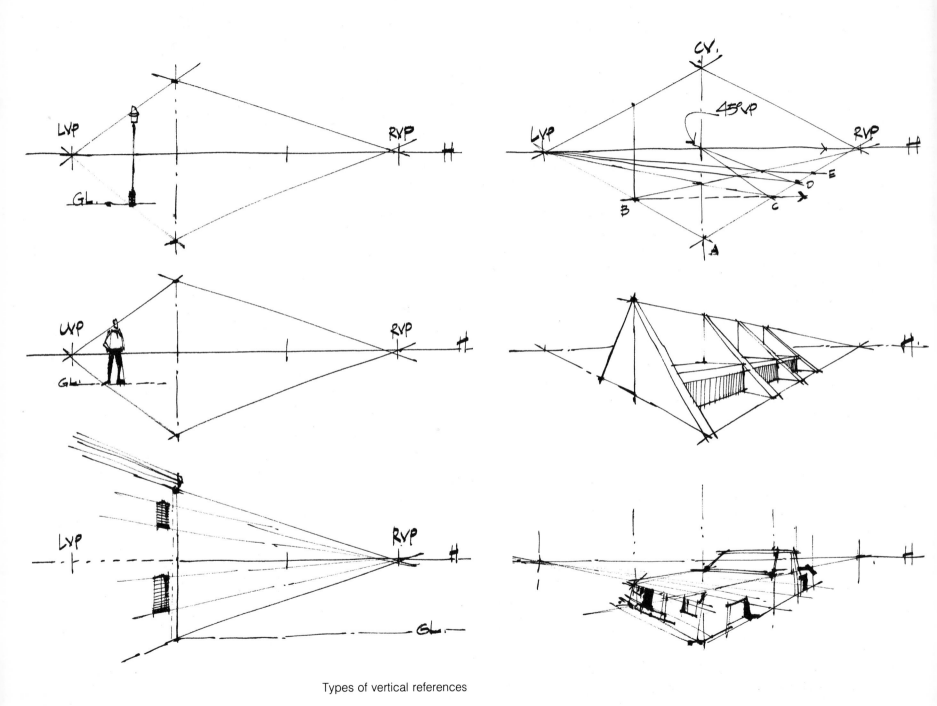

Types of vertical references

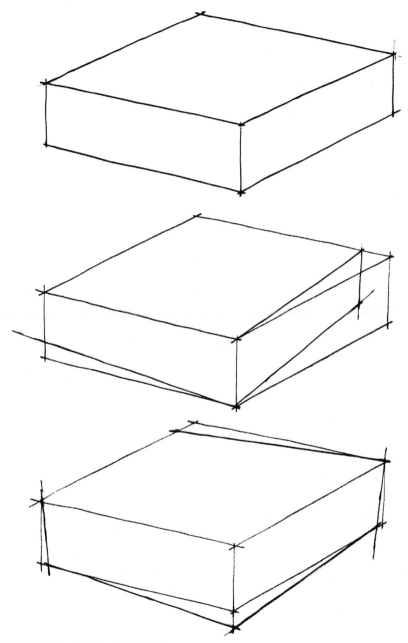

Transformation: from orthographic to perspective

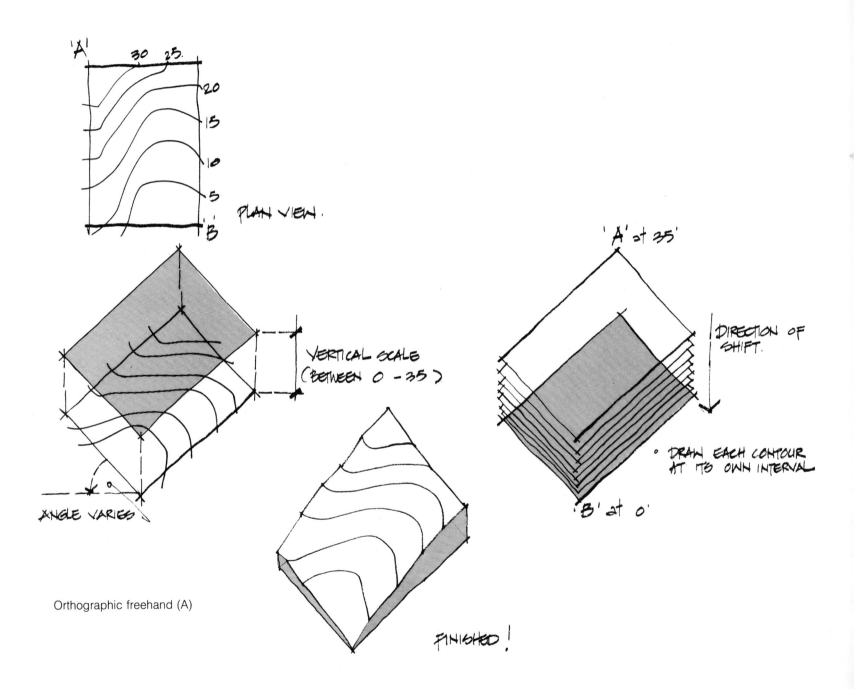

'A'

30 25.

20

15

10

5

'B'

PLAN VIEW.

VERTICAL SCALE
(BETWEEN 0 - 35)

ANGLE VARIES

0

'A' at 35'

DIRECTION OF
SHIFT.

• DRAW EACH CONTOUR
AT ITS OWN INTERVAL

'B' at 0'

FINISHED!

Orthographic freehand (A)

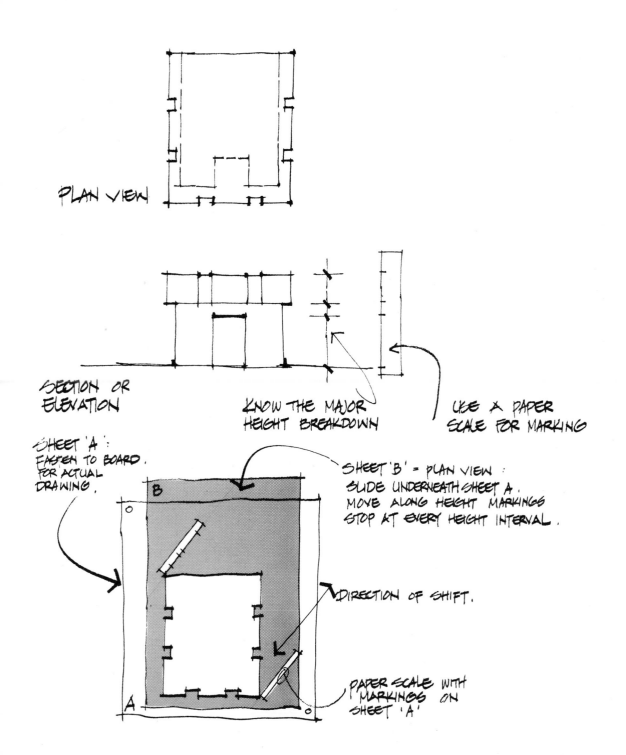

PLAN VIEW

SECTION OR
ELEVATION

KNOW THE MAJOR
HEIGHT BREAKDOWN

USE A PAPER
SCALE FOR MARKING

SHEET 'A':
FASTEN TO BOARD
FOR ACTUAL
DRAWING.

B

SHEET 'B' = PLAN VIEW:
SLIDE UNDERNEATH SHEET A.
MOVE ALONG HEIGHT MARKINGS
STOP AT EVERY HEIGHT INTERVAL.

DIRECTION OF SHIFT.

A

PAPER SCALE WITH
MARKINGS ON
SHEET 'A'

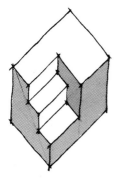

☐ EXPOSE INTERESTING
FACADES

☐ PUT LOWER/SHORTER OBJECTS
IN FRONT

☐ KEEP ANGLE OF TILT AT THE
40-50° RANGE. 45° IS IDEAL.

☐ DO NOT USE VERTICAL EXAGGE-
RATION ON THE VERTICAL SCALE

☐ ELEVATION (SIDEVIEW) CAN BE
USED AS FRONTAL PLANE

Orthographic freehand (B)

85

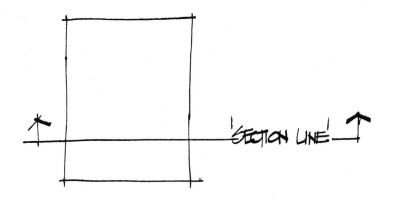

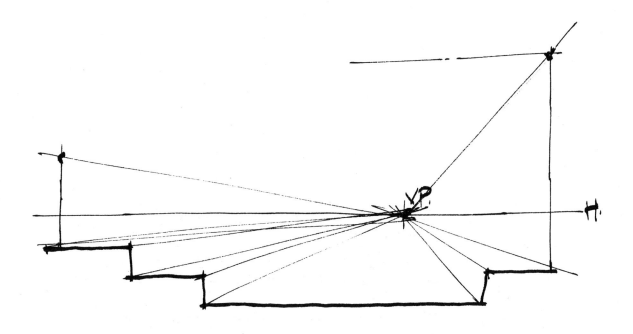

Use of section to generate perspective (A)

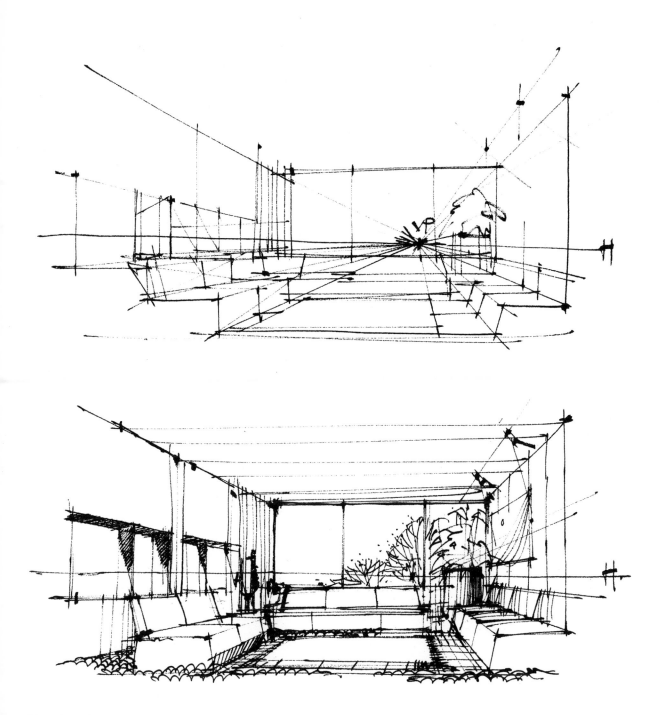

Use of section to generate perspective (B)

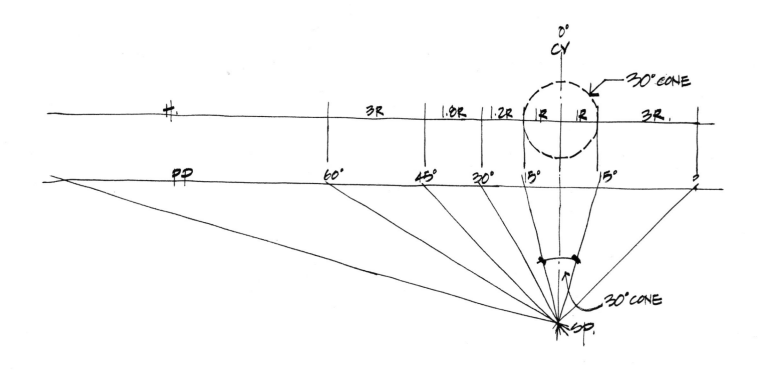

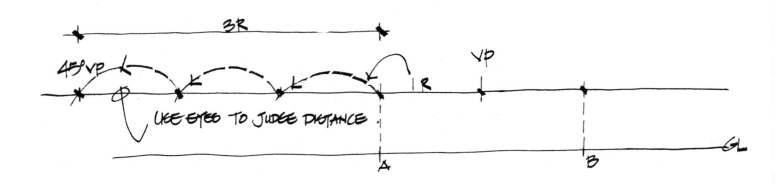

45-degree freehand (A)

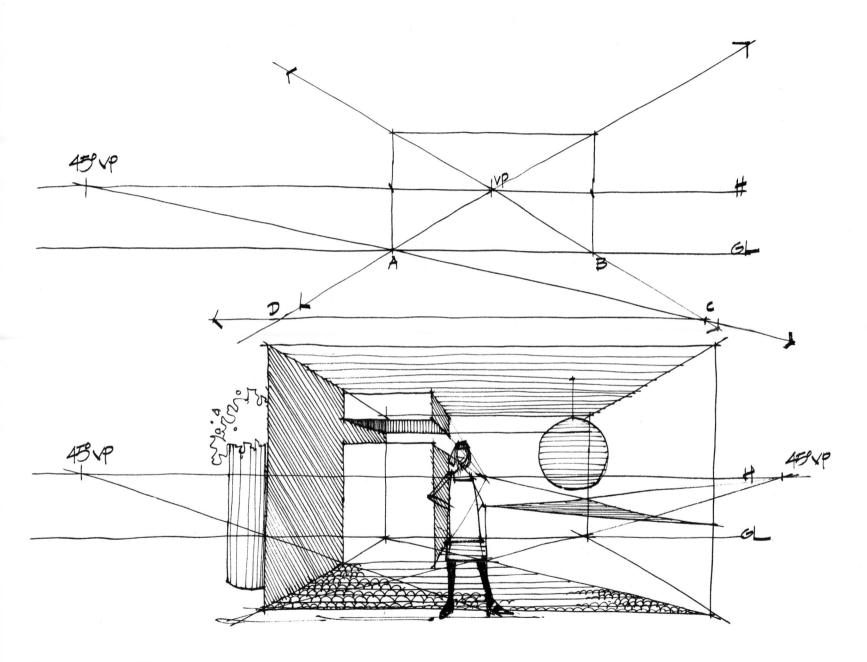

45-degree freehand (B)

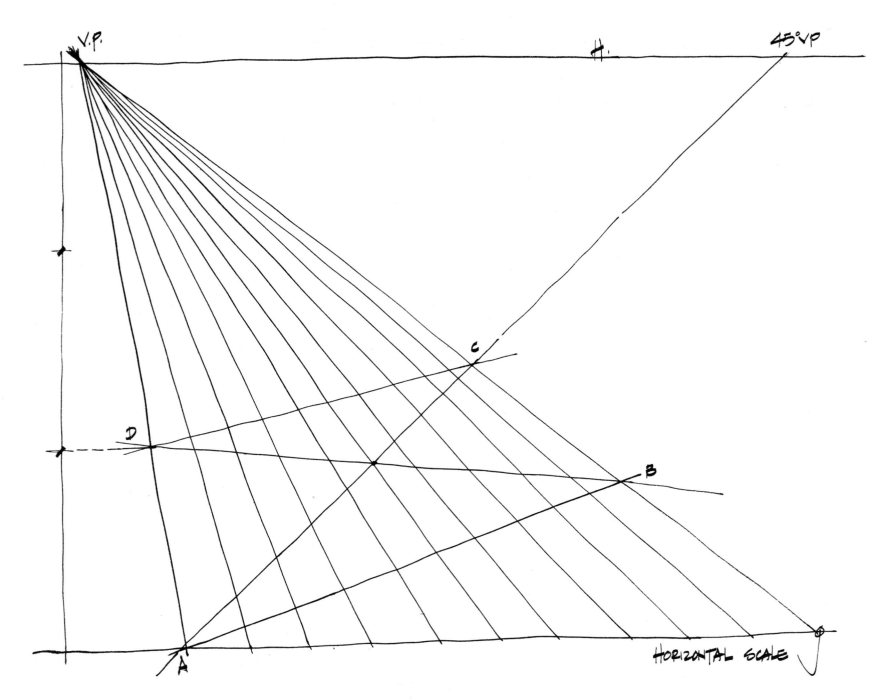

Aerial freehand: 45-degree method (A)

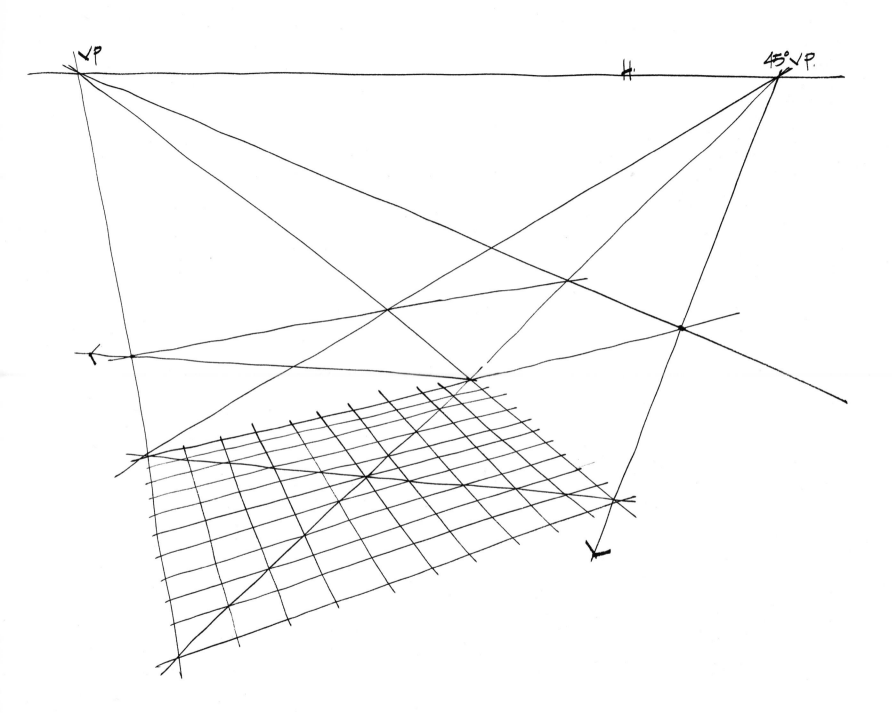

VP

H.

45° VP.

Aerial freehand: 45-degree method (B)

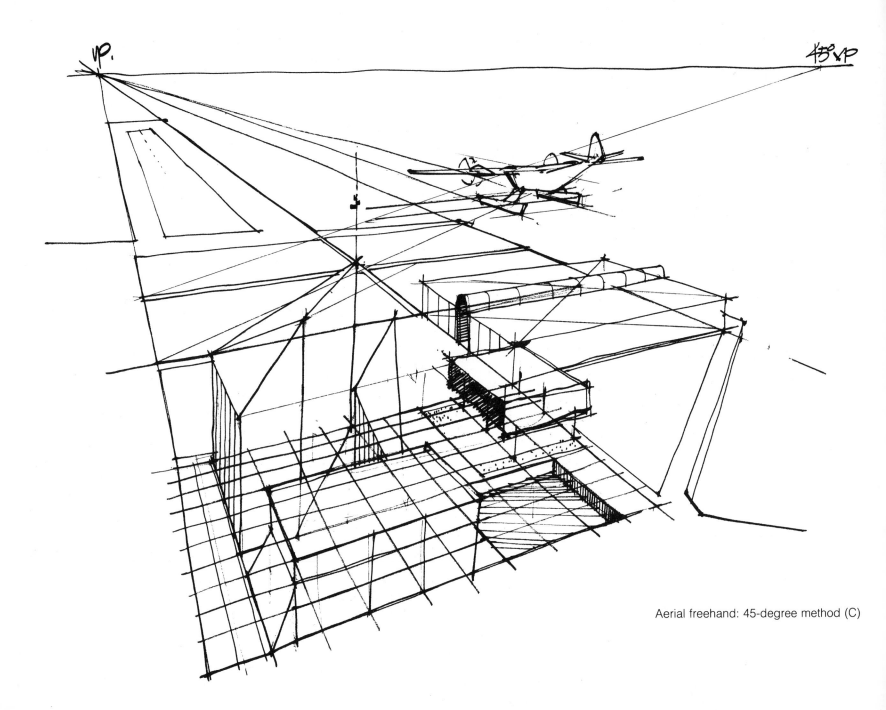

VP.

45°VP

Aerial freehand: 45-degree method (C)

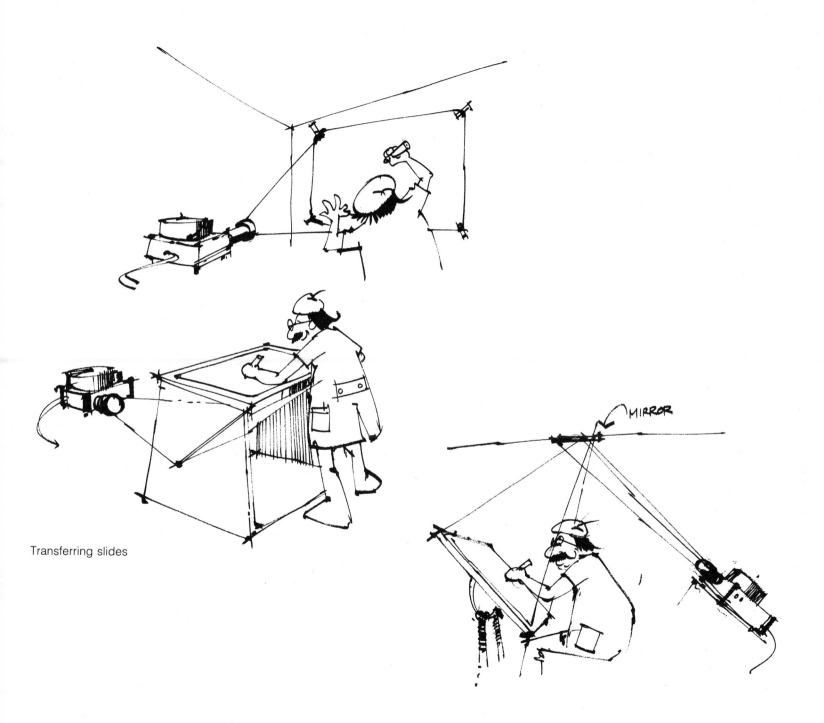

Transferring slides

MIRROR

DEMONSTRATIONS

Title: Urban Space Study
Projection: two-point
Medium: Zip-a-tone and black felt-tip

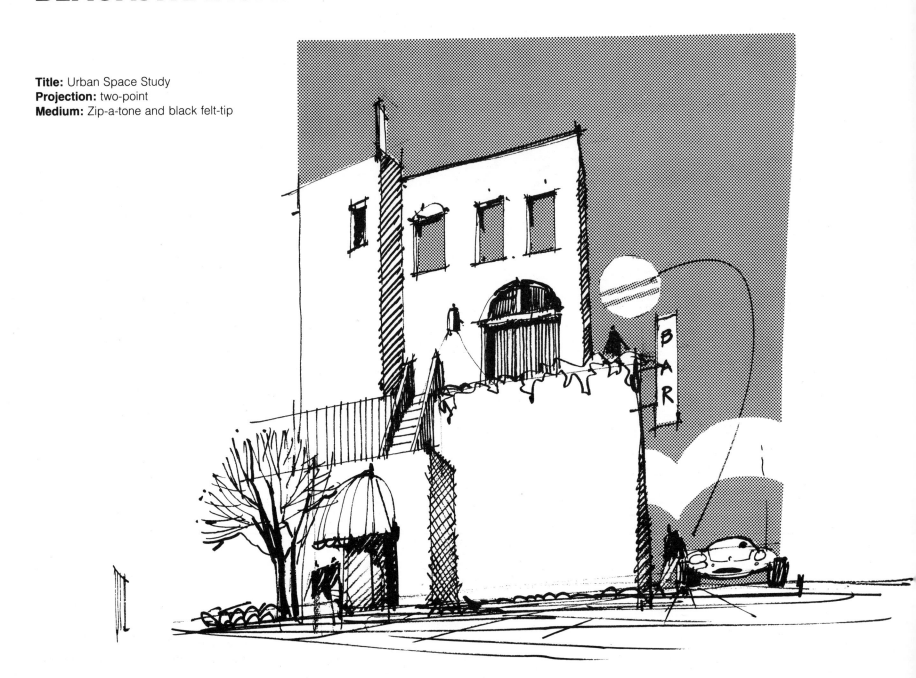

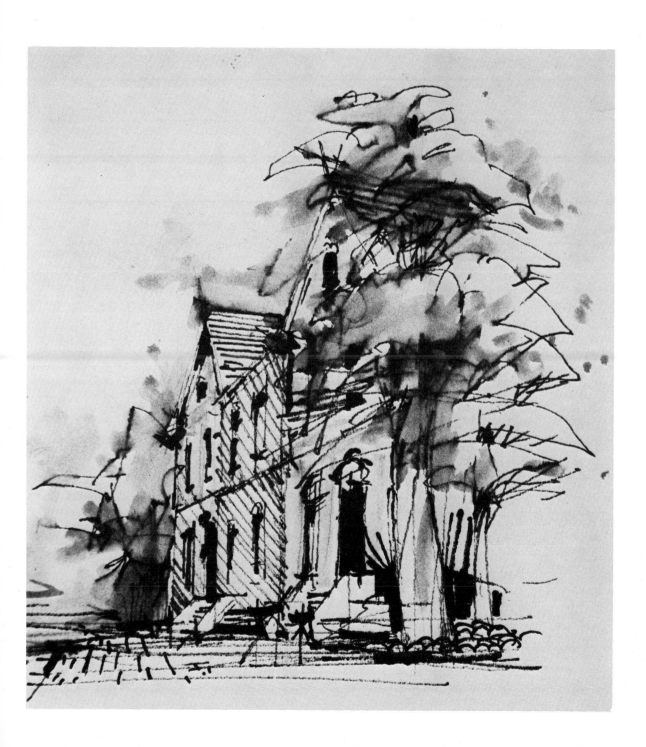

Title: Urban Street
Projection: two-point
Medium: soluble black marker and water

Title: Car-Shape Study
Projection: two-point perspective
Medium: felt-tip black markers

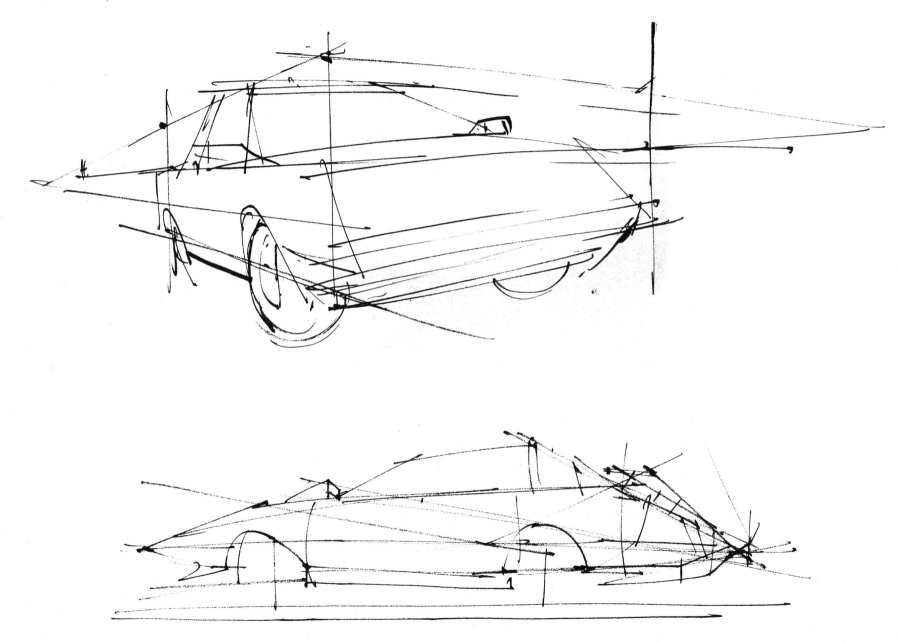

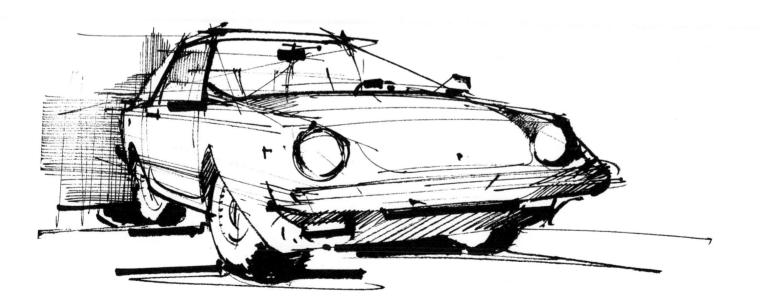

Title: Marina
Projection: one-point perspective
Medium: felt-tip black markers

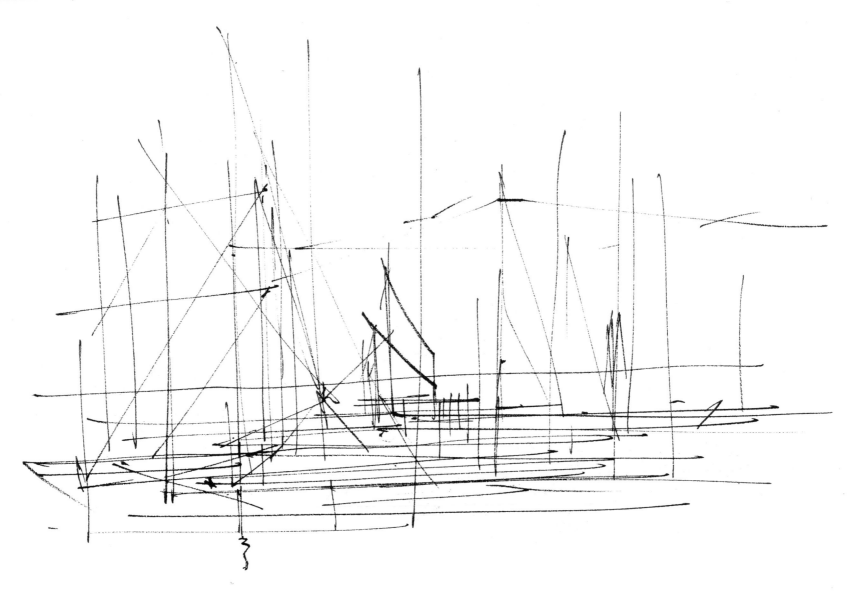

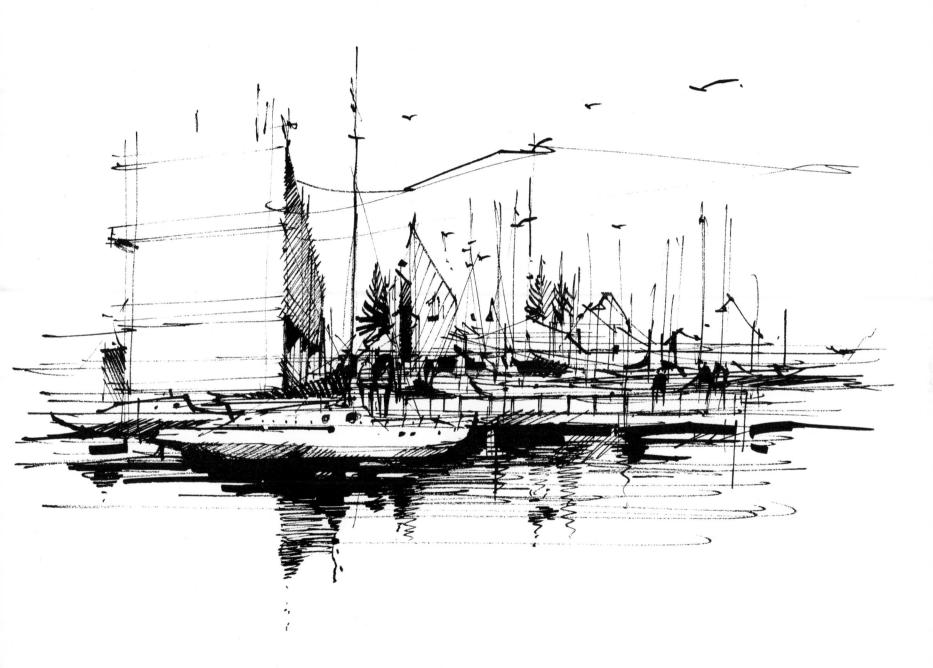

Title: Hotel Lobby Study
Projection: one-point perspective
Medium: felt-tip black markers

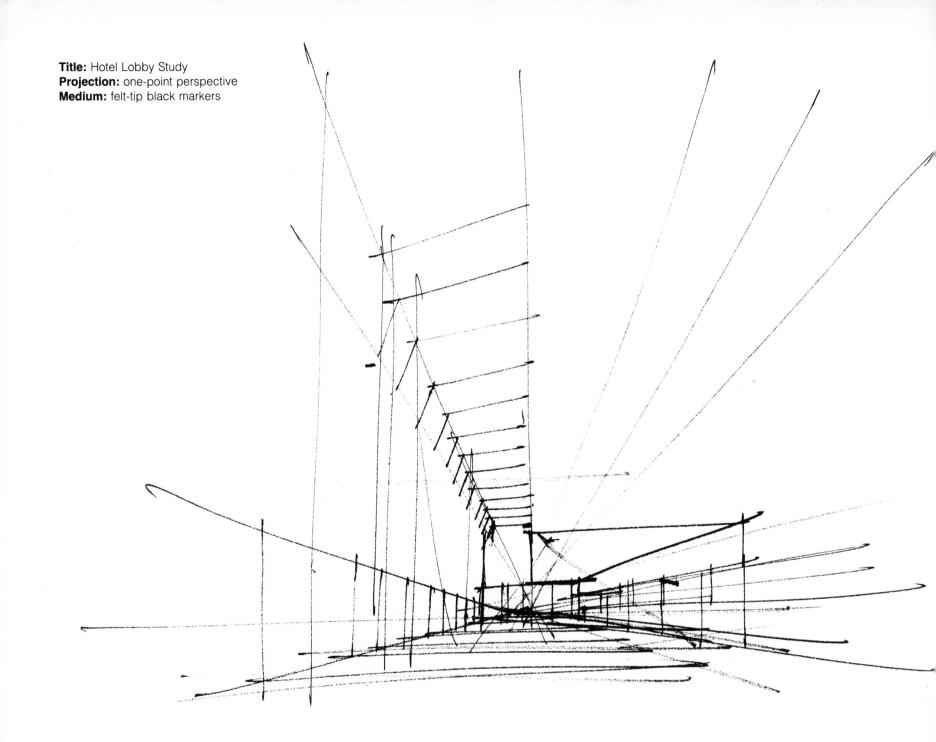

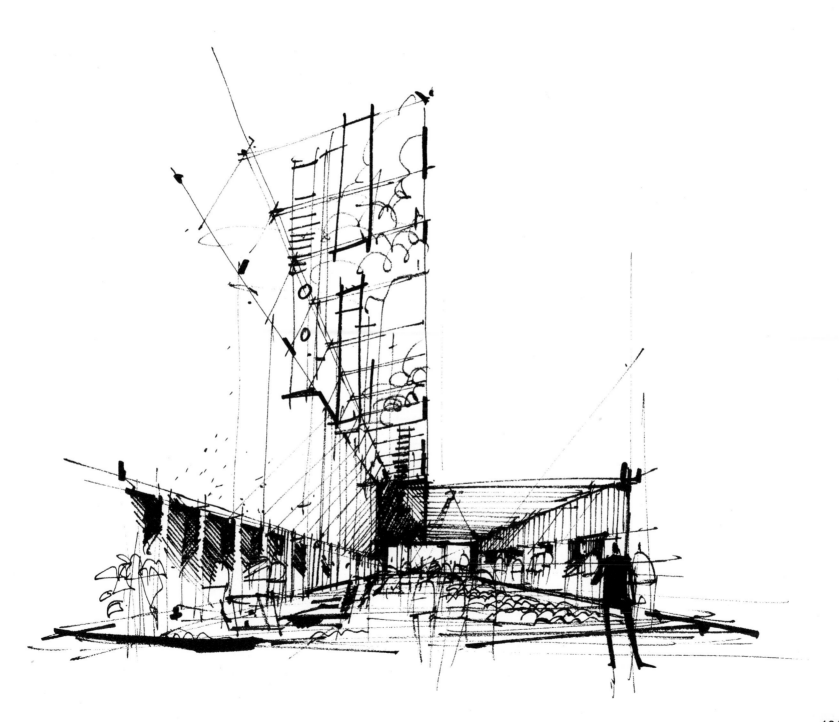

Title: Waterfront Street Study
Projection: one-point perspective with
VP to +6 left edge
Medium: color markers on marker paper

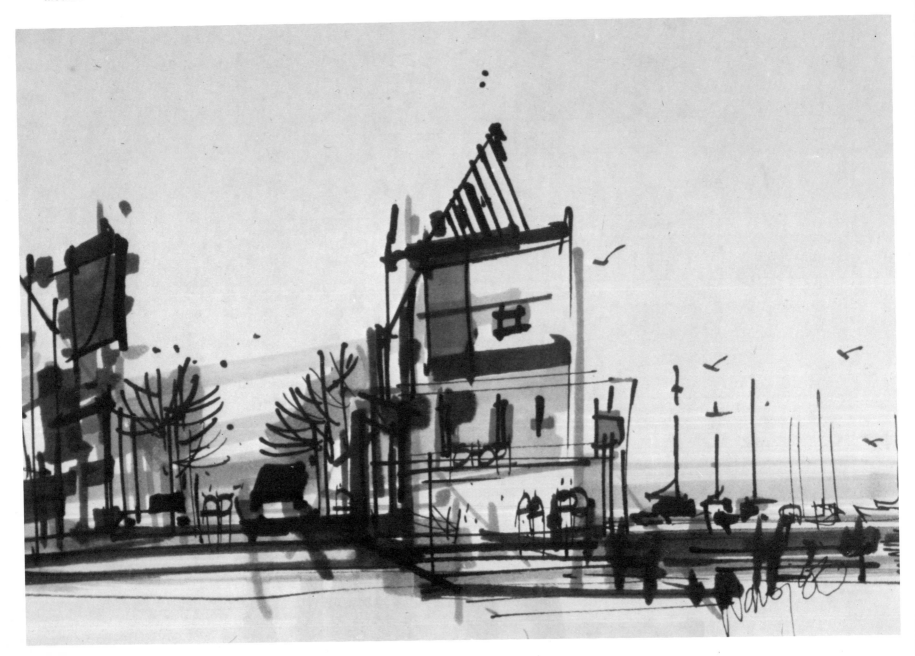

Title: Seattle Lakefront
Projection: multipoint perspective
Medium: color markers on marker paper

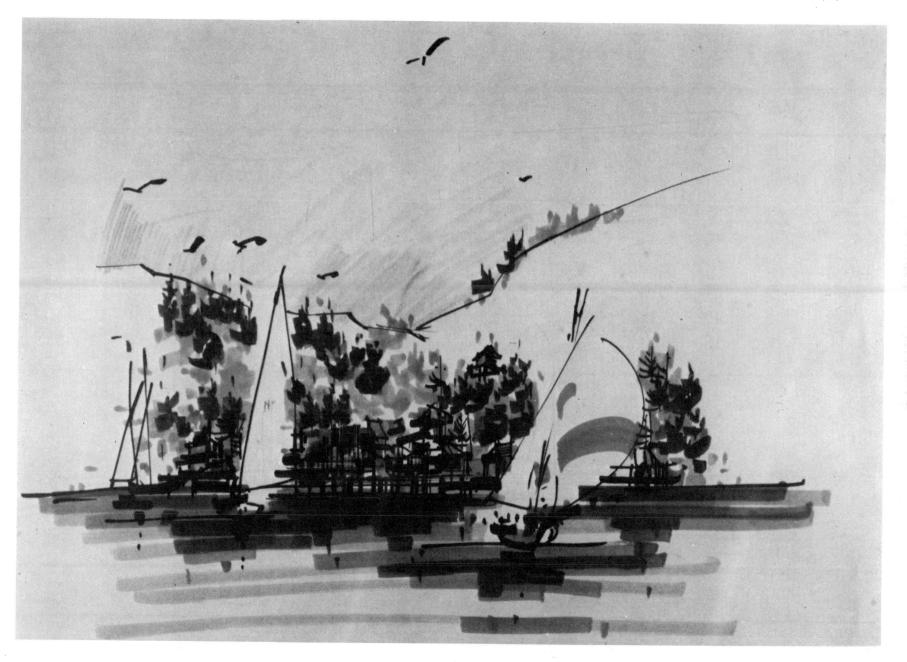

Title: Urban Street
Projection: one-point perspective
Medium: color markers on marker paper

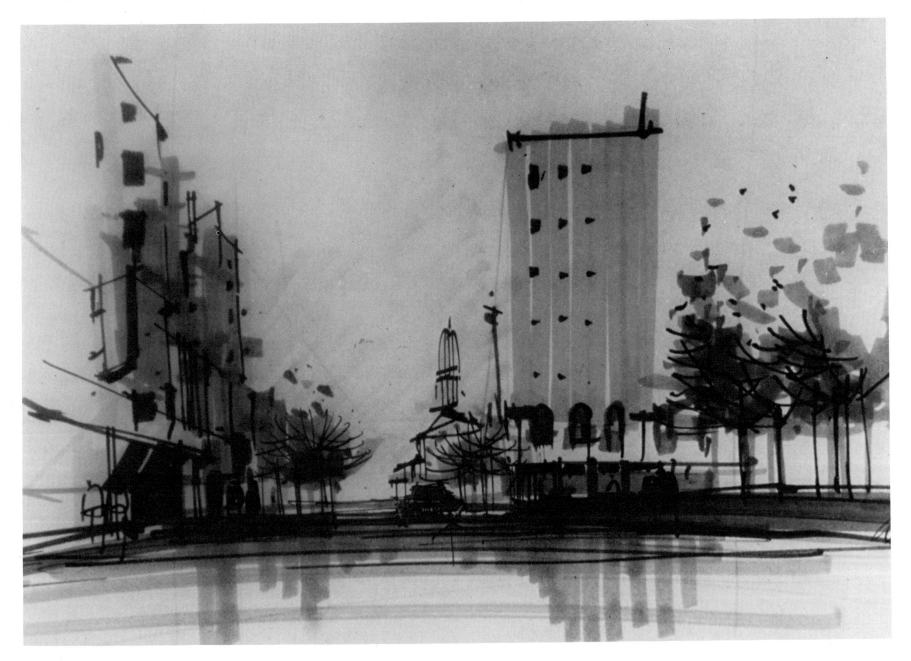

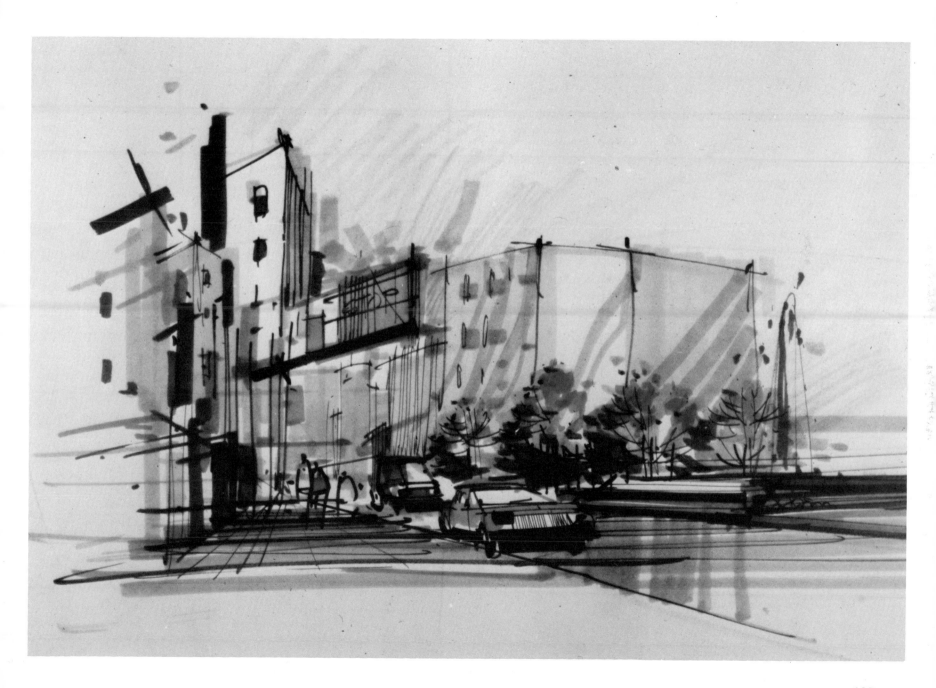

Title: Mall Spatial Study
Projection: one-point perspective
Medium: black felt-tip markers

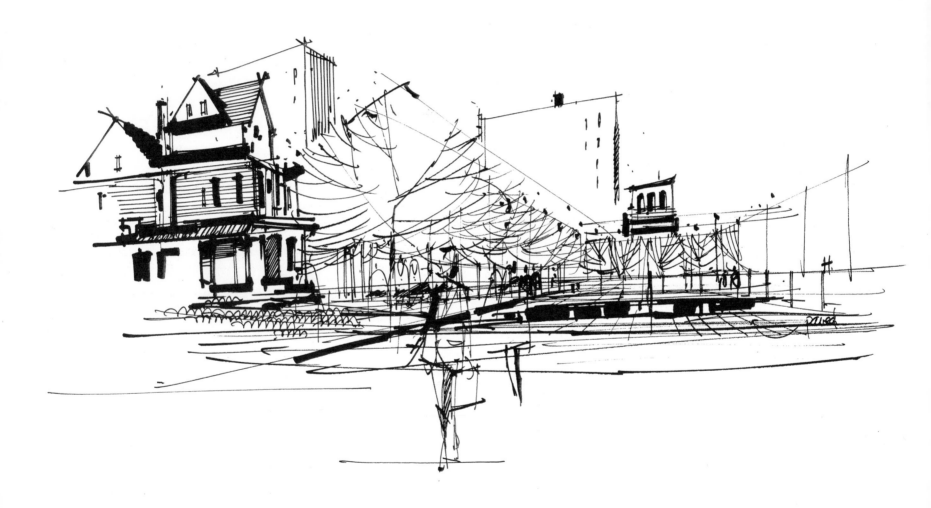

Title: Hotel Outdoor Study
Projection: two-point perspective
Medium: black felt-tip markers

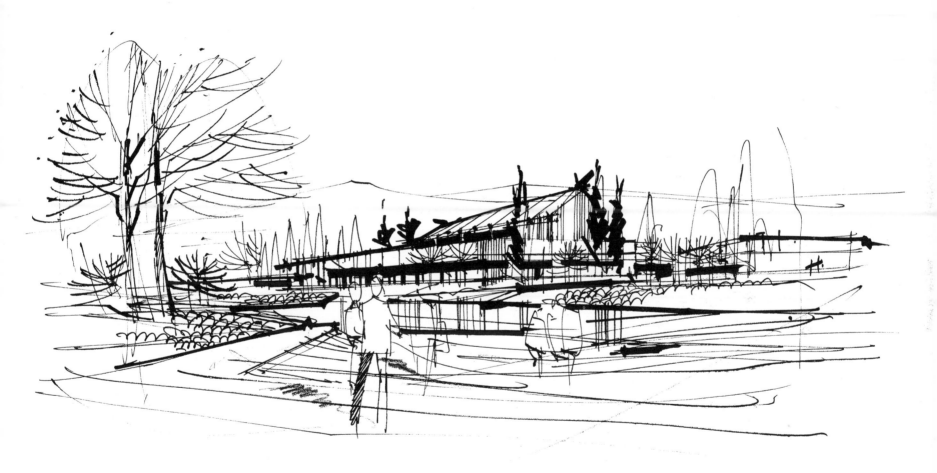

REFERENCES

Ching, Frank. *Architectural Graphics.* New York: Van Nostrand Reinhold, 1975.

Choate, Chris. *Architectural Presentation in Opaque Watercolors.* New York, Reinhold Publishing, 1961.

Coulin, Claudius. *Step-by-Step Perspective Drawing,* 2nd ed. New York: Van Nostrand Reinhold, 1984.

Gill, Boyd A. *Perspective Delineation.* New York: Architectural Book Publishing Co., 1921.

Hull, Joseph W. *Art Laboratory Manual—Perspective.* Berkeley: University of California Press, 1943.

Patton, Lawton M., and Roger, Milton L. *Architectural Drawing.* Dubuque, Iowa: Kendall/Hunt Publishing Co., 1977.

Prenzel, Rudolf. *Working and Design Drawing.* Stuttgart: Karl Krämer Verlag, 1978.

Sierp, Allan. *Applied Perspective.* Sydney: Halstead Press, 1958.

Vero, Radu. *Understanding Perspective.* New York: Van Nostrand Reinhold, 1980.

Wang, Thomas C. *Sketching with Markers.* New York: Van Nostrand Reinhold, 1981.

Wilson, G.; Holladay, D. M.; Shick, W. L.; and Shapiro, S. E. *Geometry for Architects.* Champaign, Illinois: Stipes Publishing Company, 1975.

INDEX

Title: Building Study
Projection: one-point
Medium: thin felt-tip pen with aster color wash

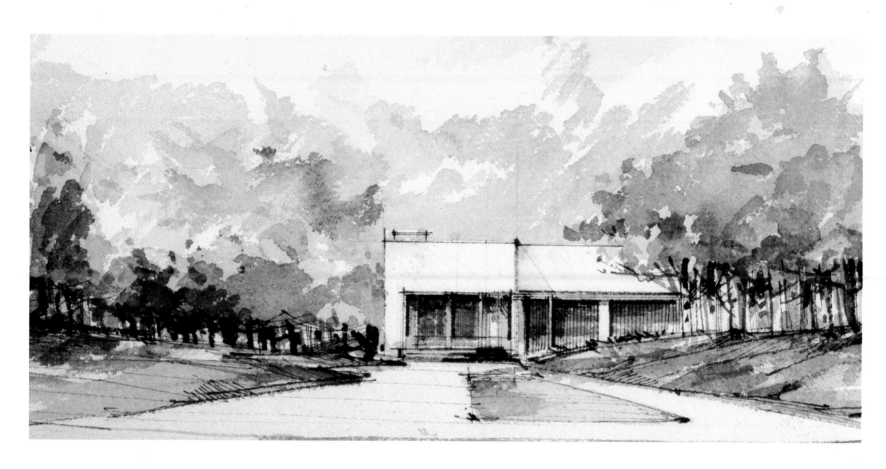

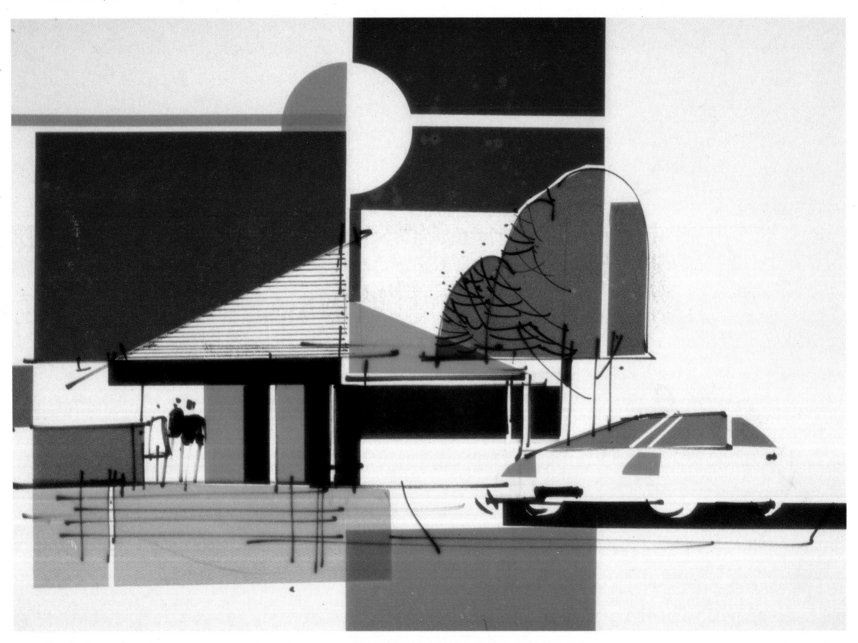